# DRAWING WITH THE
# BRUSH

Eastern
inspiration for the
western artist

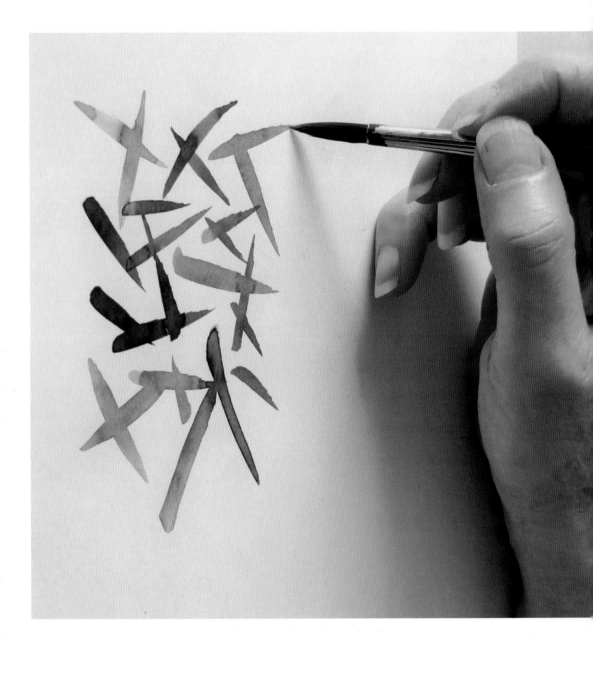

CHRISTINE FORBES

# DRAWING WITH THE
# BRUSH

## Eastern
inspiration for the
western artist

✳ THE CROWOOD PRESS

First published in 2023 by
The Crowood Press Ltd
Ramsbury, Marlborough
Wiltshire SN8 2HR

enquiries@crowood.com
**www.crowood.com**

British Library Cataloguing-in-Publication Data
A catalogue record for this book is available from the British Library.

ISBN 978 0 7198 4161 3

Cover design by Sergey Tsvetkov

**Note from the author**
This book is written from the standpoint of the artist who lives in the UK. Any descriptions or references are the author's personal overview, drawn from East Asian art and philosophy and from her own experiences of learning and teaching. They are not intended as a comprehensive standpoint on calligraphy or painting.

**Acknowledgements**
Huge thanks to Robert Stephens; Fleurie Forbes-Martin; Corinne Moore; Clive Hallett; Ian Llewellyn; Natasha Spice. Thanks too to all at Crowood for their advice and guidance in shaping this book.

All the materials in this book were supplied by Seawhite of Brighton.

Typeset by Sharon Dainton Design
Printed and bound in India by Replika Press

# Contents

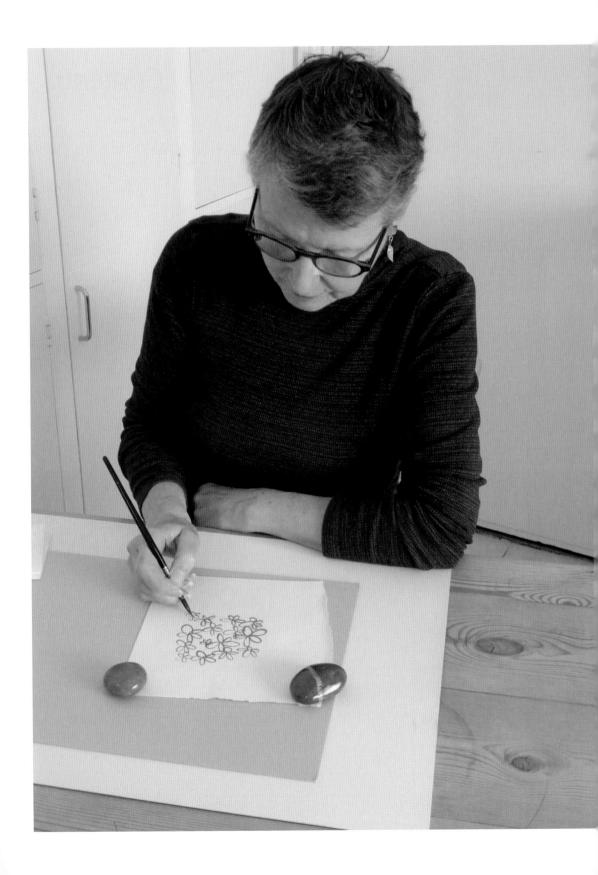

# Preface

*This book is dedicated to Rob and Fleurie.*

The inspiration for this book emerged slowly out of a sense of loss of self and from a need to find a balance between something purely visual and a more profound place, an inner voice. I started a journey that was initially a battle of two worlds: the one I grew up with and the one that I have adopted, in my mind and in my life.

It became clear that how a craft could be mastered was going to be a more important creative tool than the viscosity and materiality of paint. Perhaps there were parallels between the sticky paint and my sticky mind! My first language is visual, not linear, so images have more meaning for me than the written word. Chinese and Japanese calligraphy were the catalyst and inspiration that shone a bright light on my drawing experience. Focusing on brush-drawn calligraphy and mark making has allowed me to be 'in the moment', allow time to pass as it will and explore new and exciting worlds.

Brush drawing can help to shape a fluid realm of consciousness that disperses stressful mental states. It is a rare haven left to us in this complex digital age. East Asian philosophies too are profoundly part of this terrain.

Observing the countryside around me and absorbing nature's ever-changing scenery of sounds and smells creates a rich tapestry for the senses. I've tried over the years to immerse myself in this wonderful natural environment and to remind myself that I am part of nature and can express this through drawing.

As a teacher, my students have hugely enabled my learning. They encouraged me to get writing and the result is this book – ten years in the making. Helping others to find their 'art voice' has been both challenging and rewarding.

I have not included 'wash techniques' that are part of a painter's vocabulary. Marks, lines and the textures that a brush makes are the language of this book. It is a melting pot of curiosity, persistence, creative thinking and skill building. The drawing exercises on the following pages have been filtered by my students and myself, an ongoing enquiry on 'how to draw'. We have learnt and laughed together.

Some amazing tutors and artists have helped to install in me both discipline and patience (quite a lot to start with!), but immense freedom has arisen from this.

On the wall in my workroom is a watercolour sketch of a tree that I painted some years ago. It was done in less than five minutes: too quickly to consider exactly how I made it. Do you think I can reproduce the immediacy of this little study? Of course not!

**Left: The artist at work.**

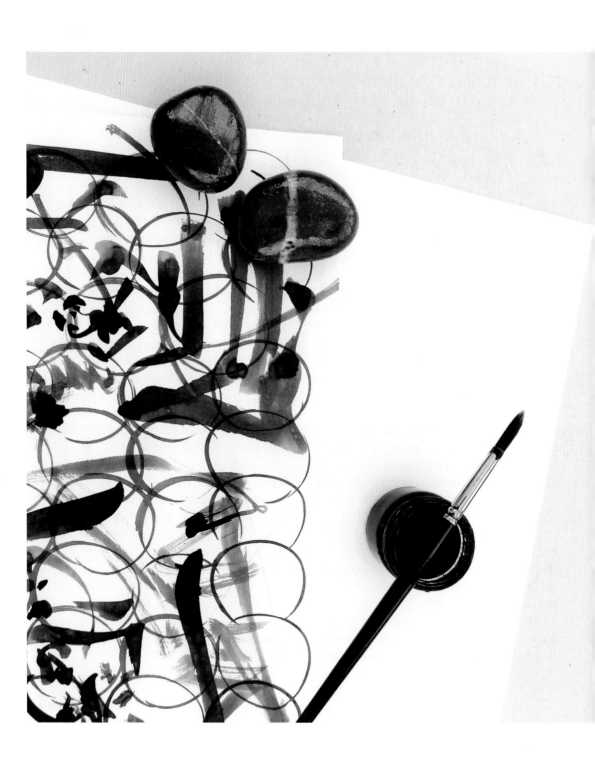

# 1 - Introduction - A New Approach to Drawing

Drawing with the brush is simple. Anyone can do it, not just artists. It will enable you to tune in to yourself. It has led me away from 'me' to a tranquil, fluid place of pure craft. The starting point is easy mark making that leads to brush practice and on to a world of pure intuition and spontaneity, a place where you can just 'be'. Nature is the perfect subject as it will always offer a sanctuary, because it is real.

Drawing with the brush is about the activity itself rather than 'what' you draw. It involves stepping off an assured path into unknown terrain. I call it 'brush drawing' because it is both 'unfinished' and yet something complete. It is understated yet it requires discipline too. If you can shake off any doubts, it is the most wonderfully fluid place in the world to be.

## Drawing of East Asia

We might refer to drawing of East Asia as 'calligraphy' but it is in reality a more mystical exploration of brush usage. The brush has been used for centuries in the East for all forms of communication. The fine marks of calligraphy emerged out of early pictograms and developed into both functional format; the 'characters' of language, and something more beautiful – an art form laid down through the artist's skilled hand. Nature as subject and man's interaction with it was common ground.

Although this book looks to elements of both calligraphy and painting to capture the essence of brush skill, it is calligraphy that leads the way into the realm of fine art through the exacting use of the brush-drawn line. This traditionally had to be done in the 'correct' way. This inheritance from the ancient masters along with their related philosophies included both disciplined and spontaneous brush craft from the earliest dynasties. Paintings and calligraphy from these early times continue to influence artists from all over the world to this day. It is a vast subject that you may wish to explore for yourself.

When I first discovered brush-drawn calligraphy, it was the brushwork skills of the classical Chinese artist that fascinated me. The natural world depicted through the visual aesthetics of line, form and space are held in perfect balance. More recently, it has been contemporary Japanese sumi-e (the art of Japanese brush painting in black ink) that has been my most inspiring guide. It is intuitive and dynamic.

There are two main differences between drawing as most of us understand it in the West, and drawing of the East. The first is different tools: pencil and brush. The second is: drawing in the West has historically been a practical exercise, whereas drawing/calligraphy of the East can be a transformational experience. Drawing universally, though, holds one vital principle: it disregards completion and is always open-ended.

A pencil is held firmly in the hand. The con-

**Left: Doodles and stones. Practice exercises have their own visual rhythm.**

nection of the hand, pencil and paper is easily felt. A 'pen hold' of approximately 40 degrees is the norm. A brush sits gently in the hand, the connection to the paper can hardly be felt at all, yet it can be used in many different ways to orchestrate a visual language of fine lines and marks.

This delicate connection between the artist's brush and the paper allows drawing to become something profound, a realm of personal expression that is available to anyone, at any time. Over the years, my brush has become part of me, not just a tool of art but part of my very existence. This has led me to an open-ended take on life, more in keeping with Buddhist philosophies as I have worked and tried to wring the living out of life through my brush-strokes. Every day is an opportunity to be brave, or as I said to one of my students who wanted to be bolder: find the edge and live on it!

Brush drawing will always speak back to you because just one brush can be turned and swept over the paper in so many different ways. It is a highly visual language that will become entirely unique and intuitive to you alone as you make it.

It is possible to come to a realization that you are someone beyond mere thoughts and emotions; that you are someone of skill who is experiencing through working. Though thoughts may bubble up, they will pass. This is an integral part of East Asian philosophy and of Buddhism. The focus is that of process and brush usage and is just one strand of a very practical learning pathway.

Drawing is always about a beginning, an emergence. It is an active way to stay in the present through 'doing' rather than 'thinking'. This is a very Zen concept, which always holds with the premise of 'this moment'. This idea, if adopted, can be incredibly freeing.

## Contemplation

Western culture has strong associations with emotional living and modern life encourages this. This can sometimes lead to negative mental states. The Japanese emphasize the need to be 'solitary' sometimes. This is not an emotional place but a self-affirming one. It can be anywhere that has peace and quiet, where we can just 'be' and allow gentle reflection.

Brush drawing can become such a place. It will allow you to unveil a pure space to work that is free from desire; a space where you can discover slowly developing skills through regular drawing routines that reward you with delightful studies that will often 'make themselves'. This is because over time you will be less concerned with 'making pictures' as we have been taught to do in the West and move to more contemplative ways of working without worrying about what something looks like.

## Starting Out

Brush drawing is a craft that anyone can learn. Patience and practice are all that is required. Ink is permanent so it encourages us to be bold.

So, how can you start? Perhaps you are keen to learn but have little knowledge and are not sure where to begin. I remember, with pencil firmly in hand, drawing the large curls and short, straight lines of the alphabet when I was five. This little memory is still my inspiration. Only now I have a brush in my hand, instead of a pencil.

The brush is the most subtle drawing tool. It aspires in the simplest way to say something. It will teach you how to focus only on what you are doing while building practical skills. Brush drawing has a visual appeal but, far more importantly, it unfolds a profound connection to the artist as they are working.

Start by following these easy, practical exercises that progress through the book. Initially, you will need only one brush, some ink and a pile of paper. Preliminary exercises build confidence through simple lines and shapes. These shapes are then used to create leaves and flowers. Later, these are more fully explored to develop a whole range of plant forms, tree shapes and finally landscapes.

Some exercises are loosely based on traditional East Asian methodologies but many of them are new ideas, honed over time. The following studies assume that the artist is right-handed, so if you are left-handed, please reverse the exercises where necessary.

Only three brushes are used for all the exercises in this book.

European influences such as observational

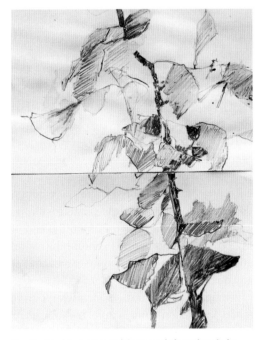

**Really looking at a subject and drawing it in pencil will give you more freedom to work with the brush later. This drawing of a rose stem explores leaf shapes, their light and dark tones.**

pencil drawing and perspective have always been relevant to the Western artist. On the subject of perspective – a European painting will display a sense of depth, something scenic through the usage of colour and detail. A Chinese painting will have a degree of 'flatness', exhibiting more metaphorical interpretations of a scene through textured brushwork and a manipulation of space as a vital aesthetic.

There are many sub-categories and terminologies that are used in Chinese and Japanese painting and calligraphy. It is a vast subject area. I have only touched on those influences that have been relevant to myself and my teaching. The overall approach in this book then is a crossing of cultural boundaries, a fusion of ideas and skills from both East and West.

Regardless of which methodologies first inspired them, the exercises focus on the way brush and ink are used to depict a tree or a flower. Each exercise is best followed as it is laid out in the book, from the start. It may not suit the 'fast track' artist. The discipline on which these exercises are based cannot be hurried. Discover instead how to draw directly and simply with lean marks that are not encumbered by the usual elaborations of painting. We look instead to calligraphy's 'art of lines' and how these are put together rather than on colour or something 'to hang on the wall'. For the artist who is looking for something more decorative, I recommend drawing on watercolour paper.

Complete the exercises in this book as often as you can. This will build your confidence and skill at an even pace, regardless of whether you are new to art, or not. This mix of brush exercises and learning strategies encourages you to discover for yourself how the brush can be employed to render fine lines and freestyle mark making. Over time, you will draw nature's subjects in your own unique way, with personality and expression.

As your work progresses, you will realize that the repetition of these exercises will find their

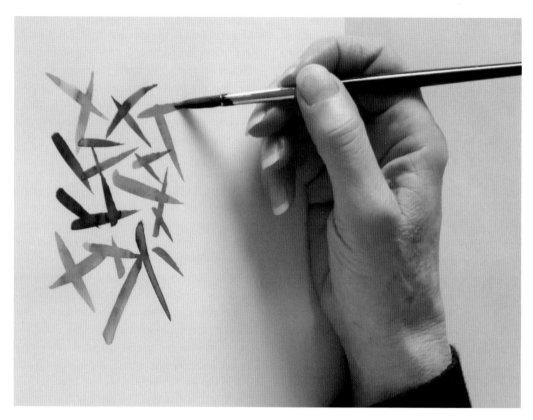

**Drawing bamboo leaves at various angles is a great way to explore subtly different hand holds and is excellent for developing your brush skill. Only a little concentration is needed. This subject is covered more fully in Chapter 5.**

own rhythm – the arm moving across the paper surface can become a contemplative experience.

Focus only on the task in hand (quite literally!). Enjoy the moment and build your own visual language.

## Nature

When we step away from our busy lives and into the countryside, we can appreciate better the wonder of nature. There is a perpetual rhythm to it, its constant cycles, ever-changing through the seasons. The countryside is a gently reflect-

ing mirror when life is good. It is a place of quiet calm when the rest of our world seems chaotic. Each one of us can become closer to nature by engaging with it and pressing the pause button on our lives for a while. Like life, nature is always untidy! Artwork that emerges from the end of my brush is an attempt to capture this world and honestly reflect my own mental habitat at any point in time.

Perhaps classical East Asian artworks have found inspiration from nature because of its purity. Early Chinese philosophy states that humans should aspire to live well within nature and contribute to its wellbeing. The somewhat elusive philosophy of Taoism is one of the most important. It talks poetically about 'the natural

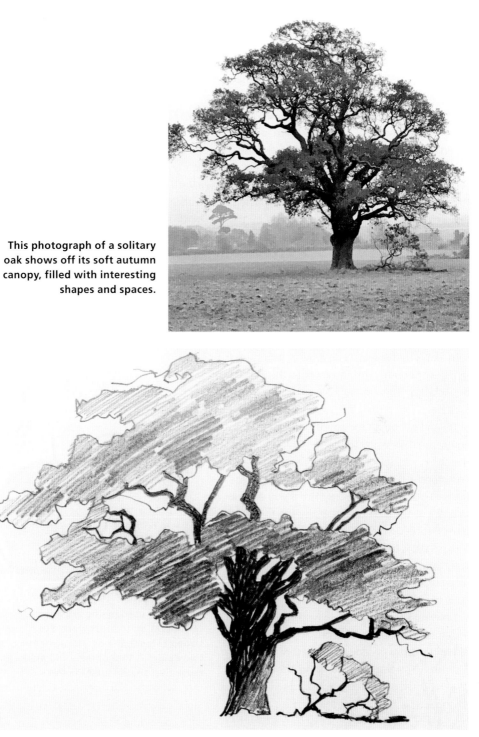

This photograph of a solitary oak shows off its soft autumn canopy, filled with interesting shapes and spaces.

This pencil sketch accents the leaf canopy shapes and the branches growing through the spaces in between.

order of things' and comments that it is the responsibility of every individual to conduct themselves in accordance with the forces of nature and of the cosmos. Buddhist-based philosophies followed on from these earlier edicts and continue today to be a practical, usable guide to living and being at one within the natural world, of which we are part. It reminds us to be respectful of all living things.

Nature has many guises. Water is as strong as rock if it freezes. Fire can destroy but its ash nurtures new growth when the fire has passed. Nature's every essence can be captured by the artist through the purity of brush drawing with dramatic effect. But the brush can also connect gently to the paper, as nature does to the eye.

Drawing all that grows and dies back is an ongoing acceptance of the world as it is at any given moment. Trees and plants are always inspirational as they transform through the seasons. If it is cold or wet, I can draw all year round in my workroom, looking out onto the garden or working from an archive of photos and sketches.

Try and get out in the countryside as often as you can. Really enjoy the fresh air and breathe deeply as you set out. What is the season and (very British) what is the weather? Feel the breeze and the sun on your skin. If you are full of angst at the start of a walk, by the time you have returned you will have a clearer view of things. Walk to the top of a hill or through woodland. Listen to the birds. Pick up some fallen bracken or some interesting leaves. Allow your stress to slip into the wind.

Drawing simple plants will help you step into a natural domain that is pro-active and self-affirming through 'doing' instead of thinking. Eventually, through experiencing the country-side directly, you will begin to see an alleviation from any emotional turmoil and start to gain a sense of equilibrium.

## Colour

Colour is of primary importance in Western art, so my early perception of East Asian art was of a 'lack of colour'. In the West, we might call art-work in black ink 'monochrome'. But in the East black ink on white paper is considered to be something powerful, even spiritual. My earlier opinions were soon replaced with an emerging understanding of the commanding presence of black ink.

For the artist, colour is a powerful visual device for portraying complex subjects that have strong emotional associations, but black

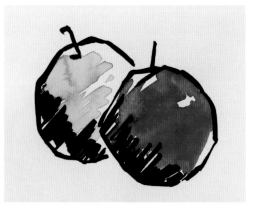

**Any colour used by the artist is a secondary consideration to brushwork. Even with two strong colours, the overall aesthetic of these two apples is that of lines and marks and it is these that should hold the eye.**

ink can connect us to an inner self, beyond emotion. The artist rendering his place in the universe through the purity of black ink on paper is a profound notion.

Initially, work only with black ink and explore all its tones from pale grey to undiluted.

Apart from the use of black ink, there are six colours referred to in this book – brown, blue, green, yellow, pink and red. (The red in a six-pack colour set is often a pinkish tint.) All other tints are premixed from these. These basic colours are readily available from all good art suppliers.

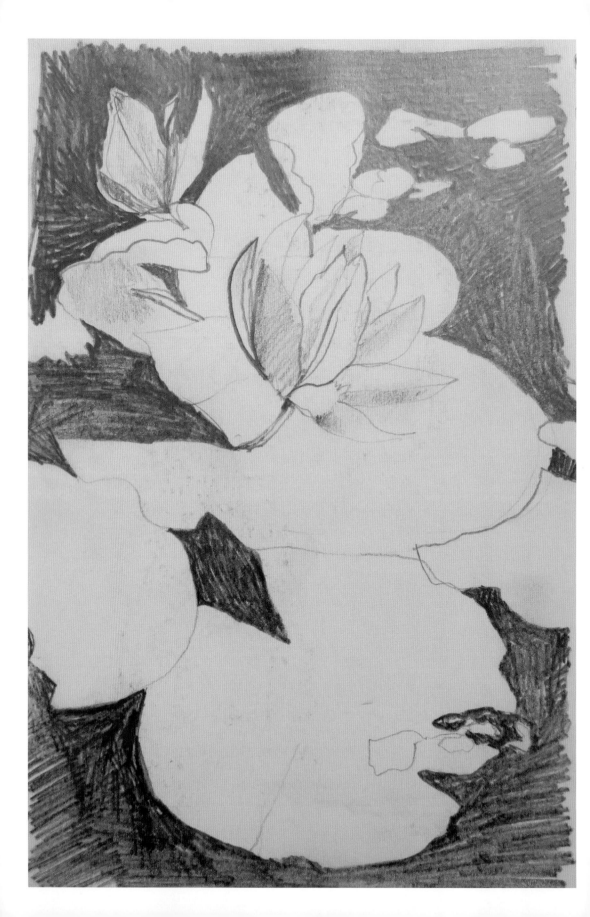

## East or West? The Four Treasures

The materials used for calligraphy are: paper, brush, ink and inkstone. These are known as the 'four treasures', a wonderfully descriptive title that conjures up an air of mystery. This title not only gives status to the great craft of calligraphy and painting, it combines historical tradition with contemporary craft too. Holding your working tools as something special means your drawing practice can be celebratory.

I don't use an inkstick or inkstone, so I have my own take on the four treasures: artist, paper, brush and ink. This model has given me a wonderful sense of unity with drawing. Be at one with your drawing materials. They will become an extension of yourself with the possibility of good things emerging.

## Ink

Black ink is incisive and self-assured. It declares its energy in every brushstroke. It may not be altered as, once dry, it is permanent. Ink is therefore dynamic and emboldening and is great for building self-confidence. Ink can be worked in layers. Light ink may be used and then a darker ink added later (or vice versa.) Don't be tempted to return to your work to 'make better'. The only way to attain a more satisfactory version of a drawing is – to do another one. It is the doing it that is important.

Traditional Chinese and Japanese calligraphy is drawn with ink in stick form, ground with water into an inkstone. The inkstick in Japan is called 'sumi' and is traditionally made with soot (perhaps from burnt pine wood that has a natural resin content) and an additional binder, such as animal glue.

Having tried grinding my own ink from various qualities of inkstick, I decided to go with the easier and quicker option of ready-made ink. Indian ink or Chinese ink are the most commonly used liquid inks and are readily available. As with the inkstick, liquid ink is made of carbon particulates or soot powder that are held in solution with shellac or other form of binding medium. A good quality black ink will be permanent and very dense if used neat.

The quality of the ink you use will also affect how it behaves with brush and paper. This also applies to how diluted with water the ink is and what type of paper you are working on.

There is a huge selection of inks now available to the artist. Explore them for yourself and find one or two brands you like.

It is a good idea to practise with inexpensive ink and paper for brush exercises. Diluted ink in water (approximately 25 per cent ink to 75 per cent water) is also economical. I keep weak ink

**Left: Lily pads, West Dean Gardens. Simple forms explored by backfilling the surrounding space with solid pencil.**

in a separate jar for practice work. Sometimes my selection of ink will be decided on a whim rather than for technical reasons. A good quality ink will render a smooth, black line when drawn across good quality cartridge or hot-pressed watercolour paper. It is for the artist to experiment with all the various products available to see which works best for them. Experiment freely with all your materials so you can become better acquainted.

Acrylic ink or powdered inks are not advisable for brush drawing as the flow and quality of the ink will be affected.

Use clean, empty ink bottles or small lidded jam jars to store pre-mixed ink in. Put a blob of this ink onto paper and stick it to the top of the bottle so you know what's inside. Keep and wash out any small bottles with lids that may be useful for this purpose.

Always experiment with some colour exercises before you use colour in your studies. Any one colour can offer a range of tones (also called tints) when you add more and more water.

One or two colours will complement black ink, but the vitality of the brush marks should hold sway over colour. Don't labour over colour decisions as this can become a distraction. Rather, select colour intuitively after experimenting with it a little. Remember you're drawing – not painting!

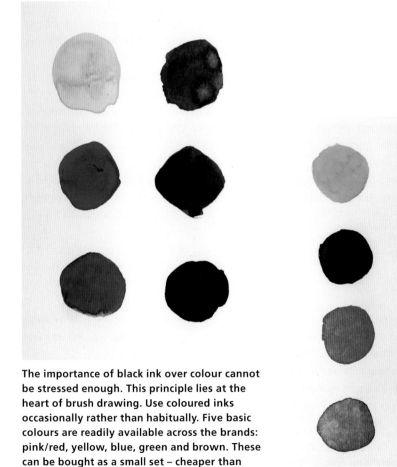

**The importance of black ink over colour cannot be stressed enough. This principle lies at the heart of brush drawing. Use coloured inks occasionally rather than habitually. Five basic colours are readily available across the brands: pink/red, yellow, blue, green and brown. These can be bought as a small set – cheaper than buying individual bottles.**

**Some simple colour mixes (top to bottom): green and yellow make lighter, fresher greens; brown and a little black; pink/red and yellow make orange; pink/red and blue make lilac.**

# Brushes

It is a common misconception that lots of different brushes will help the artist create better work. It is the skill of the artist rather than the brush type that matters.

Sometimes I use good quality materials; sometimes inexpensive products will work just as well. There are only three brushes used in this book. They are all inexpensive and good quality. I've spent years working with sable and mixed hair brushes because they hold a lot of liquid, and I do still use Chinese and Japanese brushes from time to time. However, in recent years my most used brushes have been 'watercolour'-type brushes which are perfect for starting out with ink drawing and all have a short shaft.

## Take three brushes

My most used brush is a medium-sized, synthetic hair No. 8, 'round' brush. Although titled 'round', this type of brush has a more refined point than some years ago. This is definitely an influence from the East! It is excellent for both loose and disciplined mark making.

My second brush of choice is a soft, real hair

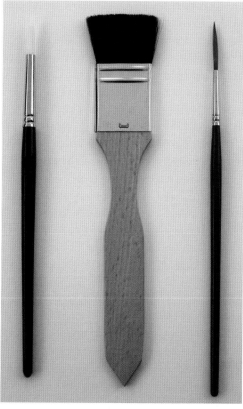

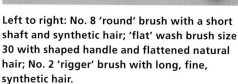

**Left to right: No. 8 'round' brush with a short shaft and synthetic hair; 'flat' wash brush size 30 with shaped handle and flattened natural hair; No. 2 'rigger' brush with long, fine, synthetic hair.**

**These are the marks that these three brushes make when you hold the brush like a pen (from top): round; rigger; wash brush.**

'wash' brush, size No. 30, 'flat'. This is 30mm across at the base and is generally used for creating washes in watercolour work. This brush is great for dynamic mark making.

Both these brushes are easy to use. You too will get used to the 'feel' of them. If you push these brushes gently onto the paper surface when dry, there is a slight resistance or spring. As my sense of touch has become almost as important to me as my sense of vision over the years, I have become more aware of how a brush feels in my hand and how it behaves. There'll be five or six brushes to hand when I'm working. Of these, maybe four will be 'rounds' in one or two sizes. Inexpensive brushes can be sturdy, create quality marks and last a long time.

All brushes behave differently. Some make firm, incisive lines, others are good for softer marks and for rendering more delicate information. Experiment often with one or two brushes till you really feel at home with them. The shapes and lines you draw will be different each day but over time you will gain a general sense of how they work for you. The possibilities are limitless.

Use only the round brush when starting out. One brush can make a huge range of marks. Get acquainted with it till you discover all the things it can do. Don't be tempted to buy lots of different brushes thinking that a change of brush will do a better job! Rather, master one or two brushes before splashing out on expensive or specialist ones.

Experiment regularly with brushwork and be playful with your mark making. Sometimes I will spend half my working time learning how to render just a few particular lines or shapes. It is always time well spent because I know that something done today will help tomorrow's drawing.

In addition to the round and wash brushes, there is only one more brush you will need to complete all the exercises in this book: a No. 2 'rigger'. The rigger is traditionally used to draw the long, fine lines of rigging on sailing ships. In this book, it has a completely different usage!

Always wash your brushes thoroughly after use and store upside down in a pot or on a brush rack.

# Paper

Chinese and Japanese papers are made differently from European paper and also have different content. Oriental papers are thinner and are usually unsized. This makes them highly absorbent. (Sizing is a binding solution that is used during paper manufacture, typically to products such as watercolour paper. Sizing protects the paper from brush damage and slows down the drying time of ink or paint.)

Newsprint is inexpensive and excellent for quick warm-up exercises. A4 or A3 sizes are handy for working. Art papers are classified by weight. Newsprint paper is one of the lightest at around 45g per square metre (gsm).

Cartridge paper comes in a variety of thicknesses (or weight) depending on what the artist is using it for. It is good for almost everything as it is strong, has a smooth surface and will tolerate a degree of wet brushwork. You can use both sides for economy when you're doodling. If too much liquid is used on this paper, it will start to ripple. All the studies in this book, apart from one or two, were drawn on good quality cartridge paper of around 140gsm. Try using newspapers too sometimes if your mind is too busy. It will stop you worrying about what your work looks like!

For more formal drawing, use good quality hot-pressed watercolour paper (HP) of around 300gsm. Watercolour paper of this weight will buckle less than cartridge paper if quite wet. It will also enable you to work more slowly if you wish because the paper is sized (sealed with gum Arabic or other sealant). Sizing on water-

colour paper may degrade after a few years so be sure to use papers in rotation, storing your newest paper underneath the old.

Explore a range of papers from a good quality art supplier and decide for yourself which paper works for you. I do not necessarily use materials or papers because they are 'right' or 'wrong' but rather choose what I have discovered about the product for myself. The manufacture of all artists' materials changes and evolves over time so it's important to stay in tune with what is available in the market.

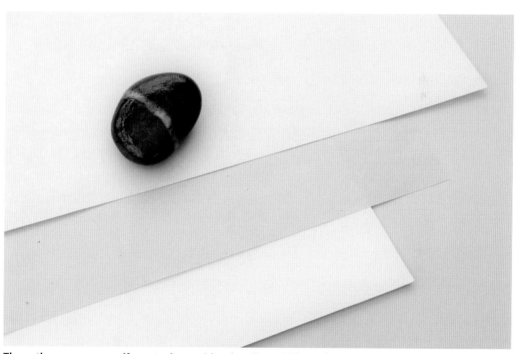

These three papers are (from top): cartridge (medium thickness), newsprint (thin) and watercolour paper (thick). Papers can be difficult to identify on screen. Best to visit your nearest art shop, feel the paper and discuss your requirements with someone knowledgeable.

# Materials List

## Paper

There are three types of paper used in this book. They are:

*Cartridge paper:* size A4, 140gsm. A ready-made pad is handy. An A3 size is useful too sometimes.

*Newsprint paper:* a very cheap practice paper of approximately 45gsm.

*Watercolour paper, hot pressed (HP):* minimum of 300gsm, cut into 8. This is an ideal size for small studies. This paper is also available in pad form.

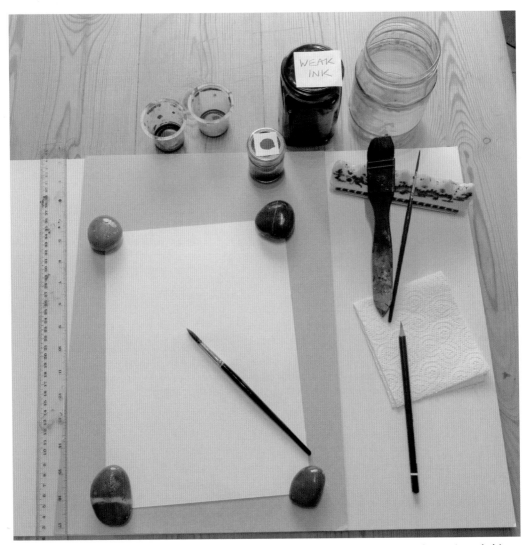

Drawing with ink takes up little space. Pebbles can be used as paper weights and an oriental china brush rack is close by for laying down brushes when not in use.

### Brushes

1 x 'round' brush, synthetic hair, size 8, with a good point and short shaft (additional size 8 brushes will be useful).

1 x 'rigger' brush, synthetic hair, size 2 (base of hair 2mm).

1 x 'wash' brush, real hair, size 30 (base of hair 30mm).

### Ink

Inexpensive Indian or Chinese ink is fine for practice but good quality ink of the same type is essential for later on. Ink products are inexpensive anyway.

**Coloured inks:** small bottes of yellow, red, green, brown, blue and pink (six packs are readily available across the basic colours).

### Other materials

Sturdy glass water jar (a large, clean pickle jar is good).

Small, clean jam jars with screw top lids. These are good for storing watered-down ink or pre-mixed colour tints.

Masking tape or pebbles, to hold your paper in place while you draw.

Small bowls for mixed ink when working. Glass, china or metal is fine.

Sharp HB pencil for sketching.

1 x plastic ruler.

Paper kitchen towels.

A china brush rack or large pot for brush storage.

# Workstation

Set up a sturdy work bench or table. A room with north light is best but not essential. My workroom faces south so I have blinds at the window. It looks out onto my garden, which is a constant inspiration (and a reminder of how much weeding I haven't done!).

It is far better to have a space of your own rather than constantly having to clear away your materials. Be sure that you can work for an hour or two whenever possible as it takes time to find focus. Try and work without interference from phone or from other intrusions.

Ink can be messy and will stain, so wear old clothes.

Your table or bench should be a comfortable height. This should not be higher than your stomach if you are sitting. Cover the bench with a sturdy plastic sheet and staple this underneath the work surface. In addition I cover this with an A1 sheet of acrylic.

Invest in a very comfortable chair that has height and back adjustments.

You may spend up to two hours at a time sitting and working so comfort is vital. The body, and in particular the arm and wrist, must have plenty of space to move freely.

Find a nature poem or two and have them in your work space to inspire you.

Your tools and materials should all be to hand but don't have the ink pots too close: about 40cm away from the front edge of your bench is good. I have upset my ink on more than one occasion and have a multi-coloured workbench to prove it! It is a good idea never to have food or drink in your work space.

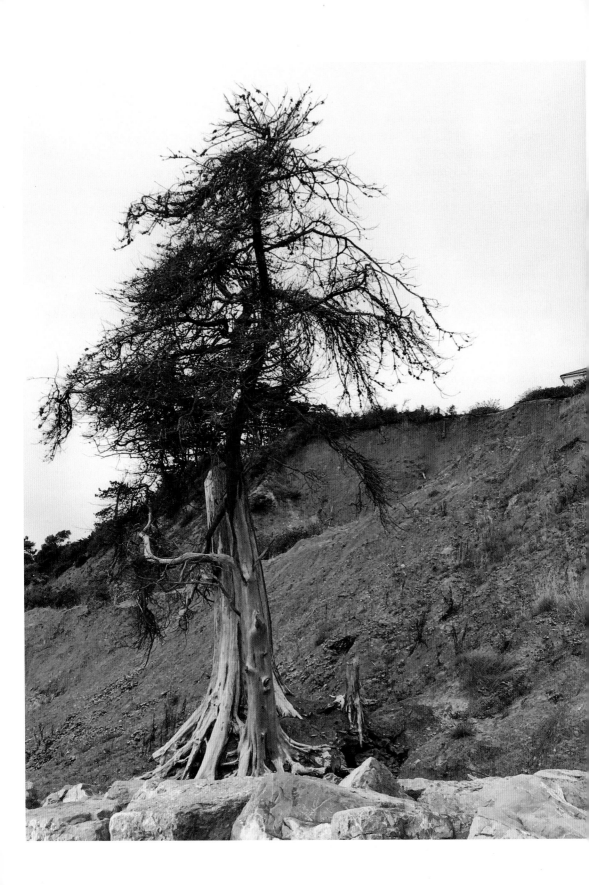

# 3 - Aesthetics of Space, Line and Form – Looking East

## About Drawing – Learning from the Masters of the East

If you're a European artist, you may associate brushes with canvas and thick, coloured paint. But if we look East, it is only brush and black ink. The most striking thing about Chinese and Japanese artworks is the power of the dark line against the white of the paper. Simple lines and marks to render plant life, trees and landscape: in fact, all aspects of the natural world. Whether the subject is calligraphy or painting, philosophy is an integral part of this artistic arena; they are interrelated and a powerful conveyor of meaning and symbolism within the culture of East Asia.

Traditional paintings were drawn with a range of specialist brushes made with natural hair, on paper or silk. They are usually termed 'paintings' whether they are in black ink or fully coloured, but the word 'drawing' may also be used. The first monks, art masters and scholars who travelled throughout China, India and Japan shared their knowledge and skill so that new, more diverse aesthetics evolved and blossomed.

## The Art of Calligraphy

Calligraphy is the art of fine lines drawn with the brush. Whether as something decorative or as a means of communication, the art of calligraphy was an essential skill within Chinese culture. Educated children from the earliest dynasties practised brush skill from a young age. One of the primary modes of learning was copying. Pictograms evolved into 'characters' and these in turn developed into highly sophisticated scripts. Adults, then, had a solid skill base on which to hone their craft. Court advisors, noblemen and scholar artists were the men of education who became accomplished calligraphers. For monks and itinerants, calligraphy may have involved replicating ancient texts or poetry. Copying was not only essential before the arrival of printmaking, it was also considered to be an act of reverence, a way of honouring those ancestors who acknowledged the greatest principles of brushwork. Interestingly, some of the most intuitive drawings and paintings will have necessitated years of disciplined brush practice.

What can we in the West learn from these art masters of the Far East? Calligraphy has an inherited ethos of practice, discipline and, in Japan, self-awareness too. Dedicated calligraphers will spend years perfecting their craft of lines and marks, sometimes as part of a spiritual

**Left: Dead tree, Devon. This distinctive tree has slipped onto the beach along with a large chunk of land.**

journey. Dedication and concentration are as one if Buddhist philosophy forms part of the equation. It was apparently not uncommon for monks to forget to eat or sleep!

There is a whole vocabulary for every aspect of calligraphy and painting in East Asia. How to sit (or stand), and how to lay out your paper and brush, is important. Brushstrokes have names; their relevance and usage are specific. Emphasis is placed on many inherited methods and precepts of the 'right way' of working.

Calligraphy requires calm and focus. It holds the spirit and essence of the artist in every brushstroke. Japanese calligraphy in particular has a wonderfully lyrical feel to it.

There are sacred scripts, poetry and many noted paintings that have survived through wars and the passage of time. Many influential 'styles' of calligraphy and painting have passed forward through the dynasties and are still referred to today by contemporary artists and academics. The subject is vast, so I encourage all artists to explore it for themselves.

The other vital component of brush craft along with copying is that of repetition. This notion may be little understood in the West for it is more closely aligned with calligraphy than with painting. Instead of 'creating paintings' with a focus on colour that we in the West have adopted, repetition involves a range of drawing exercises that are regularly returned to in order to build skill. The focus is on 'doing' rather than chasing the end product of a picture. Repetition requires patience and persistence. In China and Japan, the fine brushwork of painting can still only arise after the skills of calligraphy are mastered. It is this that lies at the heart of their fine paintings.

Calligraphy expertise is a truly technical challenge and the skills that can be learnt are unending. It has for hundreds of years been a form of art in its own right, something to be aspired to for artists of all abilities. It is still practised today in formal or abbreviated styles.

There is plenty of information now readily available to guide the curious artist.

# About Painting

The Tang (AD 618–907) and the Song (AD 960–1279) Dynasties are two most noteworthy dynasties regarding painting. Classical landscape paintings of these periods, often in vertical format, offer a sense of mystery, a glimpse of a life and era that is enigmatic and far removed from us in the West, yet we can visually at least step into this other world of scholars, monks and itinerants, and start to get acquainted.

The Tang era was a golden age of poetry and cultural development. Within the arts, academics focused on the technical, detailed merits of painting and this passed forward into the Northern School of the Song Dynasty. It was the Southern School of the Song era, however, that pursued a path of evocative, expressive painting. Known as Literati painters, the artists of this era painted more intuitively and were less concerned with painting's technicalities than with a sense of pure creativity and drama.

Landscapes from these early dynasties play with the viewer's perception of reality by mysteriously expanding as you look at them. There may be no particular focal point in a painting as everything has impact. Rather than settle on visual surety, we are invited to wonder through the scene trying to discern the water's edge, treetops or a horizon line. Any or all of this may be lost in a mist. The need to apprehend this view slowly fades. We have been transported to a magical place.

Paintings of these and other dynasties, too, hold within them a wealth of cultural and philosophical precepts that have stretched the creative boundaries of painting. Different seasons as well as multiple viewpoints may be found in one artwork. Such paintings are dramatically

different from European landscapes and display an alternative sense of reality. Technically, fine brushstrokes may be quite visible in distant views and yet details may dissolve into soft inks in the foreground. This is the opposite of what we are used to. Depth of field and perspective as we would understand it in the West has been set adrift or completely reversed. We may visually discern a kind of 'flatness,' but this is not a lack of depth, just an apprehension that is at odds with our usual comprehension of paintings.

Such imagery from the Far East was already being widely utilized in the UK by artist/craftsman William Morris and others, so this 'flatness' was not new. It took another wave of Japanese art: imported woodblock prints that arrived in France in the 1860s, to blaze a dynamic, new art trail. These prints were quickly picked up by the French Impressionists. This Euro/Japanese perspective has contributed much to a new era in Western painting.

Traditional Chinese and Japanese landscapes are usually painted in the vertical, whether scroll, banner or screen. We in the West are not well acquainted with landscape paintings displayed as hanging scrolls. Western languages are written horizontally. In the Far East, both language and artwork are traditionally conveyed in vertical format.

White paper may describe high drop waterfalls and mist around a bamboo plantation. Sharp brushwork is the perfect counterbalance to this soft, white space. Yin and Yang are at play here. This ancient code describes the energies of the earth and the cosmos, held in perfect balance. These forms in the landscape may then be strongly metaphorical and the economic brushstrokes themselves convey a powerful aesthetic that can help us engage with these inherent mysteries.

A painting may be strongly coloured. Perhaps some calligraphy has also contributed to a painting. The calligrapher himself may be a poet. The artist's 'signature' of a stamp may be joined by additional poetic comments and stamps from friends. These additional contributions take the place of 'guest' to the painting as 'host' and will affect the overall aesthetic of the artwork.

The three-dimensionality of rocks or mountains is defined with vigorous brush marks that emphasize the subject's character and may be an idealistic or symbolic overview that is not translatable. (A mountain range may resemble a dragon's back. Mount Fuji is still considered a spiritual place for the Japanese.) The quality and texture of each brushstroke has perfectly described the subject and superseded our need to see 'three-dimensionality'.

All depictions of the natural world, whether sketches or formal works, contain inherent methodologies and principles that have been passed down the centuries and are plainly visible to the Western eye. Much contemporary work sits on the shoulders of these earlier traditional principles.

## Sumi-e, Japan

Sumi-e is a Japanese form of ink painting with strong associations to spontaneous brush craft. The name 'sumi' refers to the inkstick, 'e' means painting. This is the art of black ink on white paper with a more abbreviated feel. In Japan as in China, this ink work emerged out of earlier imagery and philosophies. A focus on harmony and the spiritual through the brush-drawn line remains.

The subject of nature has always been strong in sumi and may now be freely interpreted. What stands out in modern Japanese paintings is the diversity of the brush-drawn line. Sumi-e may have a highly technical premise but it has a spontaneous feel because it is more accepting of brushwork as it appears on the paper at any

given moment, including any 'imperfections'. This correlation between artist and mark is pure Zen. It is what it is on the day. Contemporary sumi-e is therefore completely intuitive and often playful, yet it still holds the discipline of brush skill at its core. The speed of execution of some of its finest artworks belie the hours spent on brush practice.

The Japanese religion of Shintoism acknowledges that everything in nature has spirits, including inanimate objects such as rocks and mountains. It is not hard then to pick up on the earth's energies that sumi-e artworks contain.

What is 'form'? This is a very small form: a little piece of lichen. Tiny pieces of lichen can be found scattered around the countryside. They are usually a sign of a healthy environment. Find some lichen to draw with pencil and with brush.

## Space, Line and Form

What is space? The best way to get a real feel for it is to find a very large, open space for yourself – on a deserted beach or perhaps at the top of a hill. Stay a while in such a place.

Spaces can be small too. They are also important. There are a lot of small spaces among the lichen in the illustration.

Within a classical East Asian painting, there will be a balance of line, form and space, a visual symmetry. 'Line' being the brush marks that have been used with such skill. 'Form' is anything of substance that can be seen, such as a hill, a fruit or a tree. The 'space' is the white paper (although this may be much darkened on very old artworks). Of course, the white of the paper is not really space at all. Rather, it is an energized place.

In the West these concepts are often misrepresented with words such as 'stylized'; a cultural belonging. But 'style' has a rather shallow ring to it in the West. In the East it holds something much more profound as the word is directly linked to the skills of the master calligrapher.

Space has a powerful presence in all East Asian artworks. It may describe sky, river, mist or waterfall. This is a dynamic place, never

'empty,' even within domestic subject matter. Rather, it is 'something'. Simple, drawn forms such as fruit or calligraphy will also acknowledge this space.

The Japanese word 'ma' offers us some philosophical interpretations on the meaning of space. Ma refers to the spaces, pauses or gaps between all the tangible things that we experience in life. This word holds something meaningful and positive. Perhaps we can find an equivalent word that works for each of us. For me, that metaphor is 'stillness'.

Aesthetically, if the space within an artwork is to hold any merit, it follows that the drawing that it sits with must also have merit. The arrangement and quality of the brushstrokes laid down onto white paper are important, there for the artist to know and for the viewer to identify. Only drawing at its finest can allow the space on the paper to hold presence too.

# 'Chi'

In the same way that 'space' may be described with 'white paper' in a painting, chi is another vital aspect of Chinese philosophy. It is the word given to the unseen energy that flows through everything that lives and exists in the world and beyond in the cosmos. (In Japan it is called 'Ki' and has slightly different meanings and interpretations.) A direct translation of this word is not possible but words such as 'steam', 'breath' or 'air' have been used to give it tangibility. It refers to all different kinds of energy that is unseen. Visually, we the viewer can appreciate this chi within images of plants or landscape through the perfect beauty and balance of the space, line and form that each artwork displays. The experienced artist will always be aware of their own chi as they work. Traditionally, the brush being held in particular ways will enable this sense of chi. The artist is then energized to draw with focus, sweeping and turning the brush across the paper. These marks must be the truth, drawn.

Chi can also be found in the dramatic pauses used by actors on stage as well as in the words they speak. It is present in the quiet interludes that are part of a musical score, or in the case of John Cage's *4'33*, it was the whole score.

Finally, there are the gentle energies of the landscape and of nature.

In Japan, tranquility can be accessed through the experience of *shinrin-yoku*. *Shinrin*: forest and *yoku*: bathing. 'Forest bathing' is today helping stressed city dwellers in Japan get back to nature through guided contemplation. This practical therapy is now emerging in the West too.

Next time you take a walk in the countryside, pause to listen to the birds. If it's windy, look at the treetops blowing back and forth. Sit down in a quiet place and close your eyes to really listen clearly. If it's been raining, you can smell a change in the air. If in a garden, there will be the scent of flowers and the buzzing of bees. Take off your shoes and feel the earth underneath your feet. Engaging with your senses directly in this way is food for the soul and is sure to bring you back to what is important: the 'here and now'. Chi.

Trees energize us directly by oxygenating the air we breathe and by absorbing and storing our unwanted carbon. Breathing deeply in a forest's purified environment will be sure to slow down your thinking and clear the mental cobwebs.

All aspects of nature are depicted by East Asian artists and much of its imagery has been imbued with cultural myth and symbolism as the centuries have passed. Words such as ma and chi may at first seem meaningless. All we need to do is engage more with our senses. We can then step into the natural world and begin to explore the possibilities of chi, this energy of life.

# Zen Buddhism

Japan, as an emerging nation, absorbed much language and culture from China but slowly over time developed her own. The introduced philosophy of Chinese (Ch'an) Buddhism also evolved into what we now know as Zen Buddhism.

Buddhism, adopted as a philosophy or as a belief, offers us the possibility of resolving our problems of existence through awareness and personal growth. It is a passive yet positive philosophy that is completely attuned to the natural world and can be explored at any time.

The notion of self-awareness through personal conduct appeared as far back as Confucian times with its notions of 'correctness' tied to social mores. These early edicts evolved into more explorative philosophies such as Taoism (pronounced Daoism). Taoist philosophy was

one of the earliest to emphasize the natural order of things. This was a shift from 'right way' to 'the way it really is' – the way without our desire and control; the way that is laid out by the natural world. It is a meld of these early principles and later, freer philosophies that still hold true today for the followers of Zen.

If we stop thinking about 'paintings' or something visually interesting to hang on a wall; if we stop thinking about imagery in general, we are left only with what a brush can do. Our arena is then entirely about 'doing' and the busy mind is abandoned to 'this moment'.

Zen brings us the relevance of 'now'. It shows us practical ways towards mental freedom. Zen acknowledges human imperfections and our striving nature to better ourselves while accepting our mistakes. Most important of all, it shows us how to 'allow' ourselves to 'be' instead of constantly commanding our thinking to 'change' or our behaviour to 'improve'. Zen can be playful as well as profound. It only asks for good intention so it is then something experienced. It is always spontaneous and thrives on a premise of the unknown rather than 'facts'. And because every day is different, Zen philosophy allows for a fluid understanding of the 'right way' to experience the world through effort and action rather than with thought. Eventually, over time, this can lead to a more contemplative state of 'no mind' that is stress-free. There are many practical pathways to this mental freedom. The art of the brush is one of many activities that can dispel control and desire. Zen is practice. It is doing. 'Something' will occur because you have allowed yourself time to explore your craft. Sometimes this can be profoundly insightful.

As well as calligraphy, other Zen-based traditions have evolved over time as a means of quietening the mind, including the tea ceremony and the art of ikebana (flower arranging). These sometimes ritualistic tasks refer back to earlier cultures but still hold relevance because they

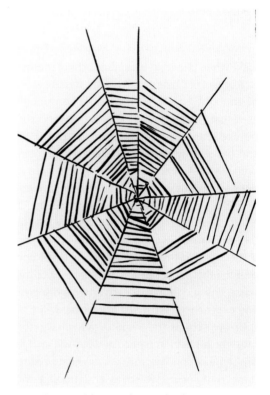

Drawing a spider's web is a playful way to engage with Zen. Webs are all different. Work freely. It doesn't matter what they look like!

embrace a quest for a state of grace that frees us by concentrating only on one particular task. One of the best books on the subject of Zen is Robert Persig's *Zen and the Art of Motorcycle Maintenance*.

There are other ways to focus before you even set about your drawing. Take twice as long as you would normally take to arrange your workbench, papers and brushes. Any physical thing done really slowly will help your mental activity to slow down too.

Zen seems to sit well within British culture. It may or may not have significance for you as an artist, but it can provide a route to mental equilibrium. Zen seems to sit well within British cul-

ture. It can be humorous as well as insightful. It has a more transitory view of life. Everything of life after all will pass, including our problems. Over time, we can access calming, contemplative terrain that is less hurried. Doors will open for us to pass through when the time is right.

Drawing with the brush can become this meditational or Zen experience through regular practice. Eventually we will stop 'expecting' and appreciate 'accepting'. Drawing as activity will finally slow down a busy brain, allowing emotional excesses to melt away. We can then start to experience a place that is free from the burden of stress or anxiety.

Buddhism refers to our ties to the world as 'attachment' because we are totally bound up with its materiality. Working within nature enables detachment by sloughing off society's demands. Nothing else is of consequence when you have simple art materials to hand. Just an hour or two together is the only time you need. Any worries will pass and a refreshed you will emerge through a naturally evolving and intuitive drawing experience.

# Copyright

While copying may be common practice in the Far East, it is important to remember that in European law it is illegal to sell any artwork or benefit in any way from something that you have copied from another artist. This book recommends that all copied work is done for learning purposes only and should remain within your own workroom. Copying should never be done for commercial or personal gain of any kind. Further details should be obtained from a copyright lawyer.

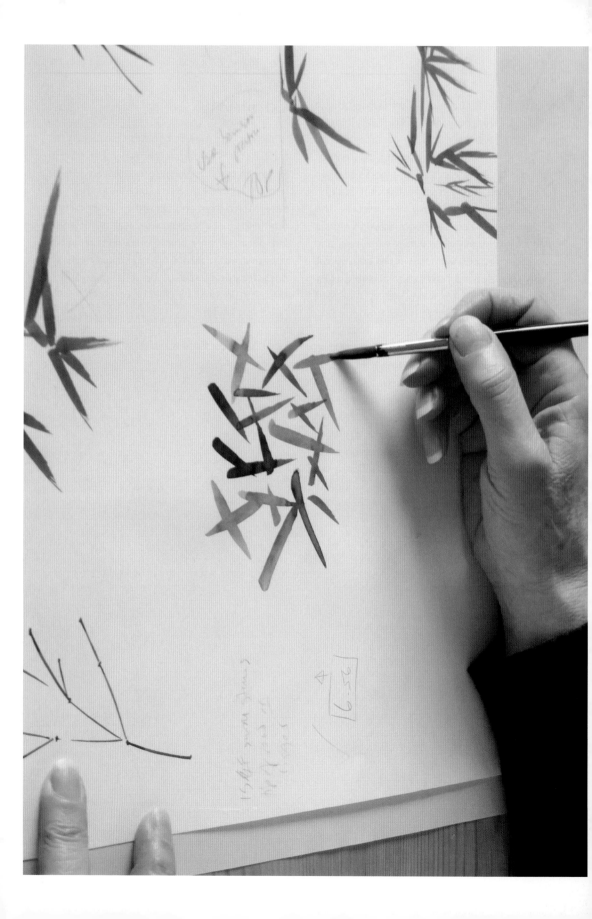

# 4 - Brush Holds and Practising Basic Marks

## The Four Principal Brush Holds

Over the years I have experimented with many different ways of holding a brush, including some of those recommended by East Asian artists. The brush holds in this book have evolved over time and are a starting point for the artist. Some are easy to adopt and some may take a while to get acquainted with. They will all become more comfortable with practice and talk back to you over time. I recommend that you start with the methods described before exploring techniques of your own.

The exercises are laid out as follows: the brush type (round, wash brush or rigger), followed by how to hold the brush, such as 'pen hold', 'vertical hold', etc. This is then followed by other working details.

These recommended brush holds have arisen out of years of brush drawing by myself and my students, and are different from those of formal classical painting of China or Japan. My take on the subject continues to evolve with time and experience.

The brush is not only an extension of your arm, it can create a bit of magic. The artist who spends some time practising with brush and line will gain confidence and freedom through both creative and disciplined drawing exercises. This level of quality can only be achieved with

**Pen hold. Hold the brush in the same way that you would hold a pen or pencil (at an angle of about 40–50 degrees).**

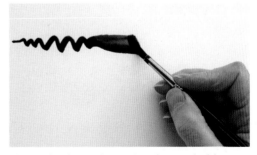

**This is the drawn line using the pen hold.**

**Left: Practising bamboo leaf shapes.**

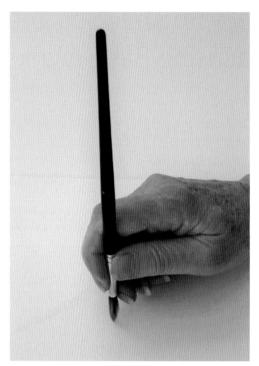

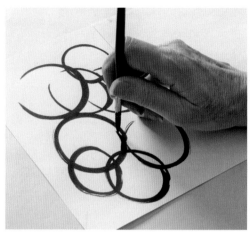

Drawing circles with the brush in the vertical position.

Vertical hold. The brush is held at right angles to the arm. This hold enables the hand to rotate freely and to generate even, straight and curled lines.

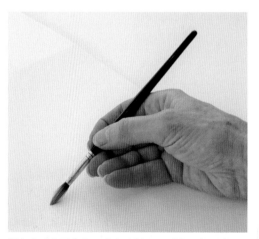

Perpendicular hold is the same grip as the pen hold but the hand is rotated slightly to the right so that the arm and hand are in a straight line and perpendicular to the body.

Side hold. This brush hold is used for drawing horizontal lines that are smooth on the top and bottom.

patience and persistence. A line drawn with a smooth, confident stroke will be apparent to both you and the viewer. You will come to know through experience if your drawing has the right 'feel' or 'look'. Later, you will discover brush holds of your own and the unending possibilities of this extensive subject. Those of you looking for a disciplined craft based on calligraphy will find a starting point here!

There are four principal brush holds: pen hold, vertical hold, side hold and perpendicular hold.

Set out your workstation with everything you will need. Mix a small amount of ink with a lot of water in a small jam jar and mix well. Approximately 25 per cent ink to 75 per cent water is OK. This is your 'practice ink'. Weak ink is best for practice work as it flows freely and is less expensive than neat ink. Keep the lid and screw it back on the jar after your drawing session to save from spillage or evaporation. Always keep inks in a cool cupboard after use. Even weak ink will go 'lumpy' if it is left too long so only mix what you need.

Have plenty of newsprint, copy paper or previously used paper for warming up. I use large pebbles as paper weights to stop the paper moving around but a little masking tape in each corner of the paper is fine. After lots of warm-up exercises, move onto good quality cartridge paper as this is a good all-round paper choice. Now try some brushwork in darker ink, with less water added.

All the images in this book, except as stated, were done on 140gsm cartridge paper.

Black ink, whether neat or diluted is all that you need initially. Later, when you're better acquainted with the behaviour of the ink, you can explore some basic colours.

Sometimes when you start out your mind will be whirring, so take a few deep breaths and shake your arms out before you begin.

## The Round Brush

The following exercises are all done with the No. 8 round brush on A4 cartridge paper.

Pen hold: dip the brush into weak ink as far as the base of the hair then drag it gently on the inside of the jar top to release the excess ink. Push the brush freely around on the paper, starting in the middle. Begin with small marks moving only your hand, then work outwards, sweeping the arm and pressing down onto the paper to render broader brush marks. Allow your hand and arm to move freely so these marks spread to all four corners of the paper. Become aware of the firmness of the brush in your hand and keep making marks till the brush runs drier. Reload the brush as necessary. Cover a few sheets of paper with large, bold marks. Now try some smaller curls and dots.

**Fill a few sheets of paper with freestyle marks and lines till you feel more at home with the brush in your hand. As the ink starts to run out, your brush will make drier marks. This is 'dry brush'. These marks give visual 'texture'. Quick, loose brush play like this will free you up psychologically and requires little concentration.**

Exercises using both pen and vertical holds are typical of how you can spend a few minutes when you first sit down to work. It is important to loosen up until you start to feel relaxed. Don't be thinking of pictures you want to paint!

Practice is the most important word within brush drawing. It is what aligns it with calligraphy rather than painting. Give yourself time to explore your brushstrokes till they say what you want them to say.

Always rinse your brush thoroughly in water and set it to one side on a brush rack or kitchen towel when you're not using it.

Slowly your periods of working will become less thought-orientated as you concentrate only on the brush travelling across the paper. Allow any thoughts to pass like clouds, focusing on what you are doing.

**Vertical hold. Continue with some random small curls and dots using the vertical brush hold. This hold enables the hand to rotate freely and render more specific marks. Try drawing with your hand just above the paper but your little finger touching it. This helps to steady the hand.**

## Tone

The word tone refers to the darkness or lightness of the ink, or as a reference to light and shadow. Neat ink from the bottle is a dense black but can be made weaker by adding more water. I usually have two jars on the go when I'm drawing: one weak ink and one strong ink. Tone is the name given to black ink strength, whether light, (weak ink,) or dark, (strong ink). Variation in coloured ink strengths may be referred to as a tint.

Vertical hold. These large circles are drawn by rotating the arm clockwise and keeping the hand static. Now do some circles anticlockwise. See also the earlier image in this chapter.

Pen hold. Here are four ink tones. Start with a small amount of water in a bowl and add a tiny amount of ink. Draw a square shape with this mix. Then add a little more ink to the water and draw another square, and so on. Keep going till you understand how this works. Finally, mix the three squares shown here: light, medium and dark. The bottom square is neat black ink from the bottle.

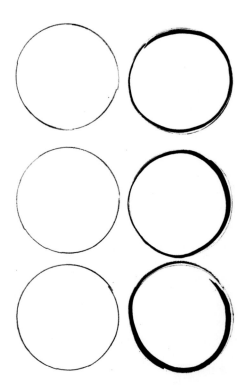

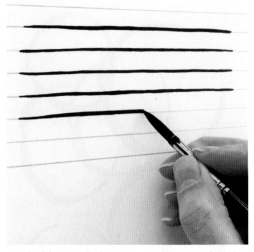

Pen hold. On ruled paper, practise overdrawing straight lines with the tip of the brush. Slow and steady works best, moving the arm and hand as one. Keep drawing till your lines get straighter and smoother.

Vertical hold is used for the following exercises:
A5 cartridge paper. Using an upturned jar or compass, draw out a whole sheet of circles in pencil. Now practise covering each one with a single sweep of the brush. As before, the hand and arm should move as one. Try some circles with only the tip of the brush. Now draw some with the brush pushed down onto the paper surface. This will render a broader mark.

Make additional copies of pencilled worksheets with a photocopier. Copy paper is fine for practice drawing. Experiment further with circles of all sizes, using both pen and vertical brush holds. Your circles may be a bit wobbly to start with but keep going.

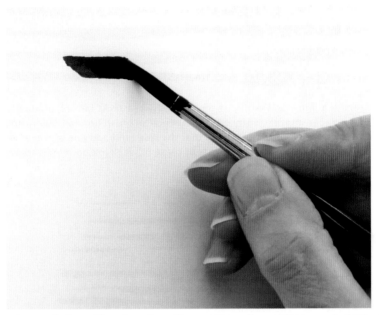

Pen hold. The shape of a broad brushstroke will vary depending on how you hold the brush. A pen hold will render a diagonal shape when you start drawing. Start drawing a straight line with just the tip of the brush touching the paper (ruled paper may be useful).

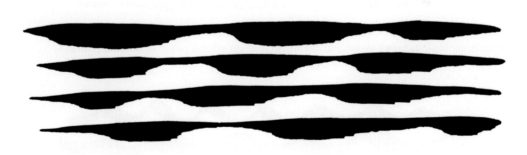

 As you draw the line sideways, gradually push the brush down onto the paper surface and then lift it up again. The brush remains connected to the paper as you travel across the paper surface using this up and down motion. Draw another three lines in the same way, creating different shapes with each line. The pen hold will create uneven shapes on the bottom edge of these horizontal lines.

Side hold. This exercise again starts with just the tip of the brush. As before, gradually press the brush down onto the paper intermittently while drawing the brush horizontally from left to right. The brush and drawn line must be aligned. Together the side hold and line of travel will render a line that is smooth, top and bottom. Practise lots of these in weak ink on ruled paper.

These exercises are all pen hold: straight lines and random spaces. Each line is drawn with a smooth, continuous brush action but the brush is lifted off the paper at random points. These lines and spaces are perfect for drawing a tranquil sea.

These wavy lines are drawn with a random degree of pressure, pushing the brush onto the paper and lifting it up, while drawing the brush to the right. When you've tried this exercise horizontally, draw some vertically too, working from top to bottom.

Each curl is drawn with a twist half way through the brushstroke. Start slowly then work more quickly. Those of you of a certain age may remember at Reception class, practising simple letter shapes like these in pattination. All letters of the alphabet can be converted easily into repeated, rhythmical designs. Create some of your own.

Vertical hold. These exercises are quite playful and use only the tip of the brush. From the top: stippling with the tip of the brush – draw these marks quickly so they look 'scattered'; small boxes (for size, these boxes are approximately 14mm across) drawn with four separate lines; 'grid'/hash; tiny single stroke circles; tiny half circles.

41

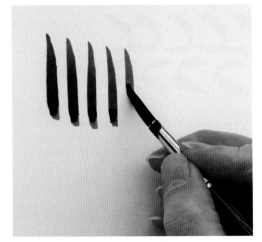

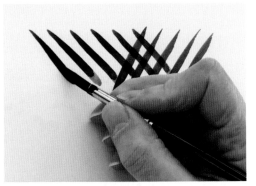

Starting on the left, draw some diagonals using the 'pulled' brushstroke. Then draw some forward-facing diagonals on top of these using the 'thrown' brushstroke.

Pen hold, 'pulled' line. These lines are drawn with a 'pulled' stroke. Only the brush tip is used at the start of the stroke. Gradually push the brush down onto the paper as you pull the line towards you. If you are right-handed, this will render a slightly uneven edge on the top, right side of the brushstroke.

This is the hand finishing the bottom of the first 'pulled' brushstroke.

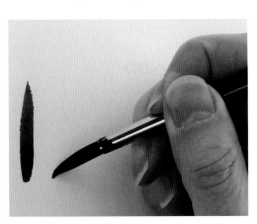

Pen hold, 'thrown line'. These lines are drawn with a flicking action. The angle of the brush changes from the start to the finish of this brushstroke. This is the start of the brushstroke.

And this is the end of the brushstroke. Both of these brushstrokes will render a broken edge on the right side that is typical of a pen hold. (This will be on the left-hand side for left-handed artists.)

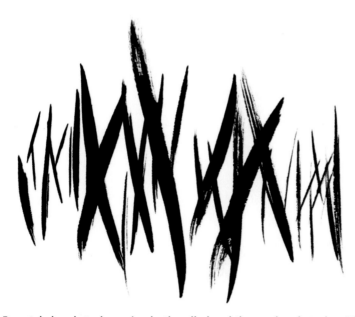

Freestyle brushstrokes using both pulled and thrown brushstrokes. The long brushstrokes are achieved by pushing the brush down onto the paper surface through the middle of the stroke. The very short strokes are made using only the tip of the brush. Execute these marks quickly to avoid wobbly lines. Practise these brushstrokes regularly.

## How to Clean your Brushes

After working for some time, your brush will pick up some residual ink. Rinse your brushes through regularly with soapy water and rinse well. Lay them on some kitchen towels or a brush rack to dry. Specialist brush-cleaning soaps can be bought from art shops for a deeper clean.

## Time

I make hundreds of ink drawings. Many of them will end up in the bin. It really doesn't matter – if I do spend hours with brush and ink it will of itself become a completely immersive experience. I will always learn something. Sometimes drawings generate themselves while time has passed me by. Try working over a long period of time and allow your ink work to emerge as it will. You may find that time can become quite elastic when you're immersed in drawing. Gradually, any ideas you started out with will be absorbed into observing what you do while you draw.

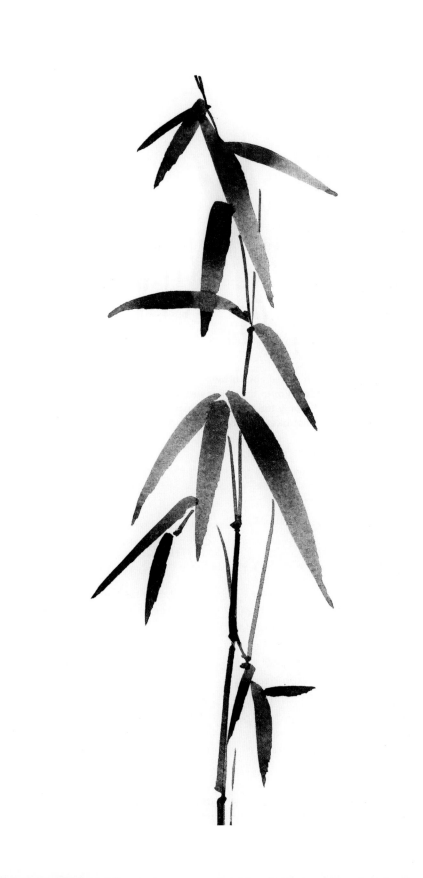

# 5 - Simple Plants

Once you've got the hang of your first exercises and are feeling more confident, move on to some simple plant forms. In this chapter we explore drawing flowers, leaves and fruit.

Nature's dramatic changes can be relished through all the seasons. Each day brings something new. Draw from all of nature around you: landscape, plants and trees; flowers as they burst into bloom and then die back in the autumn; trees laden with foliage and then transforming into architectural shapes as the leaves fall. Try some observational drawing too with pencil and sketchbook. This involves really looking at your subject matter while you're drawing it. Spend as much time as you can sketching in this way.

How can you, the artist, then convey these pencil sketches into brush marks? Simply is the word! The curls and lines of simple brush exercises can now be put together to create bud and leaf forms. Each day is a fresh opportunity to work quickly and with greater assurance. You may have some project in mind but keep that at bay until later. Try not to cast a critical eye over your work but continue with both disciplined exercises and some loose brush drawing too. It is very important to allow yourself time to generate work freely.

Begin to recognize the relevance of white paper in and around your ink drawings. It will let them 'breathe'. The more it appears, the more you will appreciate its contribution to the overall aesthetic with the ink.

## The Seasons: The Four Noble Plants

… if in your thought you must measure time into seasons, let each season encircle all the other seasons…

*The Prophet,* Kahlil Gibran

The 'Four Noble Plants', as they are sometimes called, are profoundly symbolic in East Asian art. They represent the four seasons: orchid = spring, bamboo = summer, chrysanthemum = autumn, and plum blossom = winter. (This last plant, commonly referred to as 'plum', is in fact a Japanese apricot.)

These plants are of particular importance as they are a visual poem of both seasonal changes and the human condition. They are all hardy enough to endure the weather shocks of the Far East between one season and the next; they remind us that we must be adaptable. They are also symbolic of many ideas and philosophies of the Far East. The historical usage of these plants in artwork may be spiritual, evocative and often

**Left: Single stem of bamboo. Bamboo is a deeply symbolic plant and used throughout Chinese and Japanese art. It is strong and adaptable.**

complex, allowing the viewer to explore any underlying stories or meanings. I include all four plants as they contain key brush skills. These brush exercises may vary from classical precedents.

Although it is the simplest of leaf shapes, bamboo requires much practice to render inkwork that is dynamic and has visual 'presence'. I therefore recommend starting on bamboo exercises after the flower subjects.

## Orchid

The orchid flower is fragile with a delicate fragrance and is valued for its elegance. Drawing orchids combines small, delicate brush twists for the flower heads with the long, sweeping strokes of its leaves.

## Bamboo

Of all plants, it is the bamboo that is seminal in Chinese and Japanese art philosophy and history and is a much referenced subject with regard to brush techniques. A bamboo painting may be just a simple, small study on paper or an elaborate painting. As with many other plants indigenous to the Far East, bamboo is a deeply symbolic plant: tough and upright; it will bend into the stormiest weather without breaking. Scholars and monks have been inspired for generations to render the bamboo in ink. It is the perfect subject for practising simple, swift brushwork with skill.

Drawing bamboo embraces the leanness and qualitative brushstrokes that are required for drawing both Chinese characters and calligraphy but steps from language into artistic image. Perhaps this is why brush-drawn bamboo continues to hold a powerful visual aesthetic, as it is the greatest technical challenge for all brush artists. There is much modern imagery on how to draw bamboo but the artist should look also to the great masters from the seventh to seventeenth centuries for inspiration. The legacy of this subject can be seen in art collections and museums worldwide.

## Chrysanthemum

The chrysanthemum is hardy – it arrives late in summer and continues to flower into the autumn with blooms lasting for several weeks. Beautiful and colourful, it symbolizes the ability to withstand temperature change. It is tranquil, dignified and harmonious, and is the perfect subject for exploring many florid brushstrokes.

## Plum blossom

Plum blossom symbolizes persistence and beauty as it often blooms in the chill of winter but offers the hope of spring. Its perfect little buds and flower heads offer the artist the rhythm of fine, curved lines drawn one after another. The stem meanwhile combines a fine and broad brush mark that can be rendered with one sweep of the brush.

It is the scholar painters of the Song Dynasty who are most closely associated with depicting these four plants. There are several classical art books that continue to be available in reprinted editions. One of the best is *The Mustard Seed Garden*. This book was first printed in the early Qing Dynasty (seventeenth century). It is an excellent, comprehensive book of brush exercises, imagery and comment that artists can use to guide their drawing techniques. The English edition is also full of Chinese characters, so you can discover for yourself the relationship between brushstrokes as language and those of image.

## European plants

There is a huge variety of plants in our temperate climate to choose for drawing. In this chapter I've included the rose, the foxglove and the Michaelmas daisy as well as an oriental favourite, the wisteria.

# The Quality of the Drawn Line – One Brush Makes Many Marks

The fine lines of calligraphy, whether short, long or broad, are executed confidently and smoothly, sometimes very quickly, like a 'sword thrust'. Wobbly lines (unless intended) are usually caused by overthinking, being tired or just a lack of practice. As a musician practises scales, so you too are a musician of lines and marks. Draw regularly. Your work will get slicker. I do simple drawing exercises to this day.

There is one golden rule when drawing with the brush: one or two brushstrokes is better than many. Less is more in East Asian aesthetics. There is much beauty in a leaf drawn with only one brushstroke.

With every season you can discover something new to draw. Often it's something you've never really noticed before. Do lots of pencil drawings before you start with ink and brush. Bring a little of nature inside too by scattering a few leaves across your workbench. Perhaps a couple of lichen-covered twigs or a small jar of flowers…?

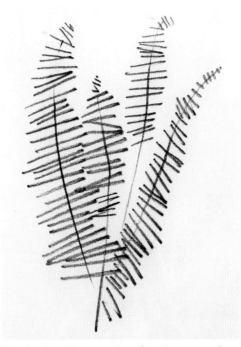

**Simple plant forms such as fern leaves can be described with just a few lines of pencil. Drawing such subjects will help to build confidence.**

Try these two exercises using both pen hold and vertical hold. These shapes are great for rendering flower bud shapes such as fruit blossom and crocus.

**Start with a curved 'M' shape. Using only the tip of the brush, work these loops in a row, all the same size and shape. Apple blossom is a flattened 'M' shape with a small gap at the base of the flower. Use one stroke of the brush for each flower.**

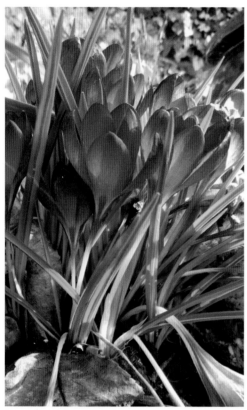

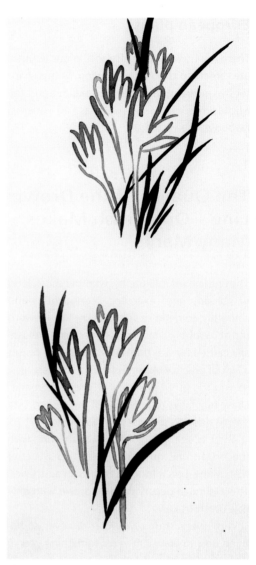

This photograph of a clump of crocuses formed the basis for the following two sketches using coloured ink.

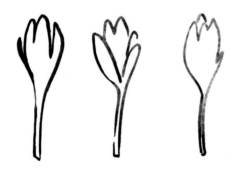

These two drawings explore the rearrangement of flowers and leaves while keeping a focus on the essence of the plant.

Pen hold. Draw these crocus stems with longer brushstrokes using only the brush tip. When the brushwork comes more easily, do them twice as quickly. Repeat this exercise using a vertical brush hold. Compare both brush holds for line quality. Find some images of similar flowers to copy.

Try the vertical hold for the following exercises, using only the brush tip.

This same technique can be used for six-petalled flower heads such as jasmine.

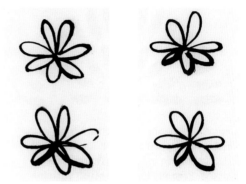

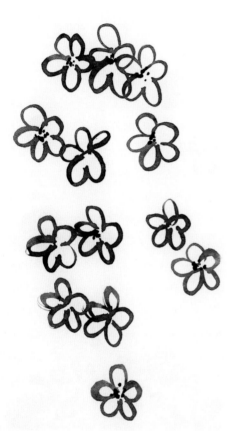

Forget-me-nots (five petals.) Practise some small circles first. Each flower head is drawn with only one brushstroke. Add a few dots with the brush tip for stamens.

Finally, try some larger flower heads using the same shapes. These may take a bit of practice and may involve both hand and arm movement. Each flower is drawn with one brushstroke. Fill a whole sheet of paper and your hand will find a natural rhythm. Recharge the brush with ink as needed.

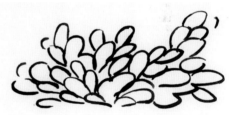

This is a leafy shrub using the same fine line worked in loops.

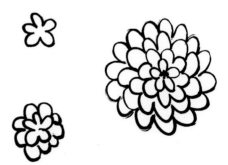

Finally, try a chrysanthemum head in three stages as shown.

Find some interesting shrubs of your own to draw in this way.

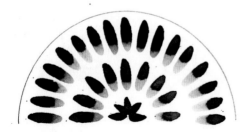

**Sunburst. Pen hold.** This pattern is great practice for a 'pressed' mark. Draw a semi-circle 10cm wide in pencil using a plate or compass. Partially load the brush with ink (drag the brush gently on the inside of the bowl to release some of the ink). Press half the brush head gently onto the paper, which will render these delicate petal shapes. Move the angle of the hand slightly for each mark. Longer, broader petal shapes can be achieved if you push down a little further onto the paper.

## Sunflowers

Pressed marks. The following varied petal shapes are created by applying different pressures to the brush. Practise some of these marks on their own till you get the hang of them.

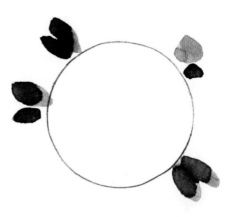

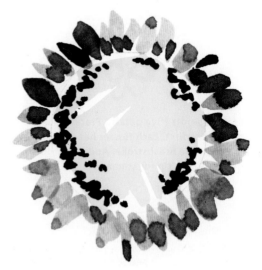

Draw a pencil circle of approximately 45mm. Draw some petals at random points around the circle, some with the brush tip facing out and some with the brush tip facing towards the centre of the flower. Complete your flower head with a variety of marks. Add some weak yellow ink when the work is dry.

Try this exercise again, rendering some petals in light ink and some in dark. When this is dry add some weak yellow ink in the centre. A cluster of seeds can be added finally with the very tip of the brush using neat black ink. Note the subtle variety of petal shapes and the small spaces around the edge of the central seed head.

## The Rigger Brush

So far you have used only one brush and will have discovered how creative it can be.

The second brush in this book is called the 'rigger'. You'll need a No. 2 rigger made of synthetic hair. This type of brush comes in a few sizes and you can identify it by the longer and fewer hairs it contains. It was introduced to me by two talented artists whose painting weekends I used to attend in the West Country. Roger Clemens and Les Matthews did much to inspire their students. This brush was but a small part of their generous teaching.

The rigger gives the artist the facility for long, fine, straight lines that were traditionally required for painting the rigging on boats. But it can also be used successfully for quite jagged mark making.

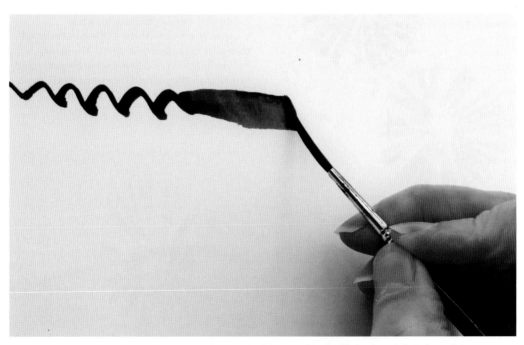

**This is a drawn line using the rigger in the pen hold. Less than half the brush hair length is connected to the paper yet the brush still renders a broad line.**

This brush takes a bit of practice to master but then it becomes invaluable for creating free and spontaneous line work. As with all new-to-you brushes, try out your rigger brush with doodles and cover a few sheets of paper. Start using it with a pen hold. Then experiment with a range of hand angles between pen hold and vertical hold. Finally, try drawing lots of vertical and horizontal lines till you get the feel of it.

The following exercises are all drawn with the rigger.

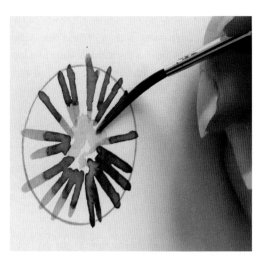

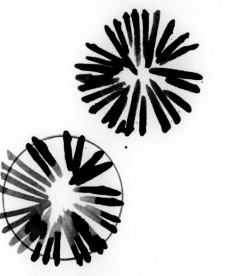

Michaelmas daisies. Pen hold. Draw some circles approximately 4cm across in pencil. Load the rigger with weakened ink and press the brush flat to the paper for each petal. You can turn the paper slightly for each brushstroke or adjust the angle of your hand to render smooth-sided marks. These two flower heads were drawn by moving my hand rather than the paper. Work some petals with the brush tip in the centre of the flower.

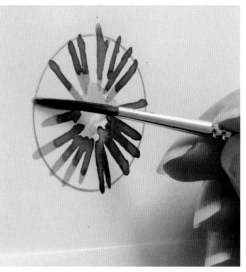

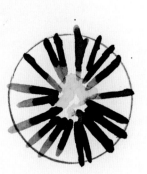

Every flower form is unique.

The remaining petals are drawn with the brush tip on the outside. Spacing between the petals should vary. Finish the flower head with dots of yellow ink when the petals are dry.

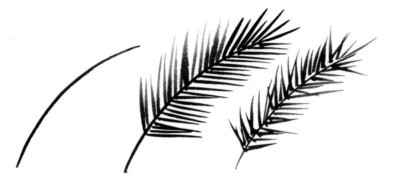

Fern leaf. Pen hold. Only the tip of the rigger brush is used for this fern leaf, shown in four stages. 1. Draw the curved main stem of the leaf in pencil. 2. Overdraw this pencil line with the brush travelling away from you in an even arc. 3. The fronds are drawn from the main stem outwards using 'thrown' brushstrokes. Work steadily along each side of the stem from the bottom, keeping the marks closely drawn. 4. These leaflets are of different lengths and cross over here and there to give them a natural look.

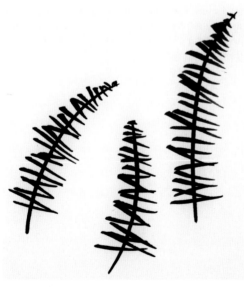

As you settle in with your new brush, try practising thrown lines at all angles. This will be useful for drawing fine grasses.

Practise drawing single fern fronds both horizontally and vertically to get used to working the brush at lots of varied angles. Pick up the pace a little as you draw.

## Reeds

Reed seed heads should have a wispy look to them. This is done with 'dry brush'.

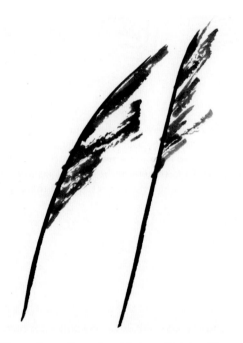

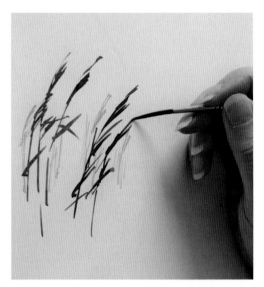

Rigger. This reed study is drawn with light and dark ink, worked in two stages. The leaves are all drawn in the same direction to give a slightly windswept look. Draw each leaf with just the tip of the brush, using a quick thrust from left to right.

Stems: Draw these in mid-strength ink with a bold sweep of the brush, throwing the line to the right. Rinse the brush. Seed heads: Load the brush now with weak ink then wipe it lightly on a paper towel till little ink remains and the brush is nearly dry. Using the perpendicular hold, lay the length of the brush head against the reed stem and sweep it lightly to the right. This will give a light texture that describes the subject matter perfectly.

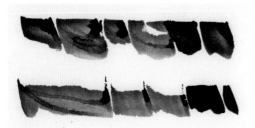

Perpendicular hold. This brush hold is the same grip as the pen hold but the elbow is drawn close to the body and the hand and arm are in alignment, perpendicular to the body. Load the brush well with ink and drag it on its side so that almost the full length of the hair is touching the paper. Draw 'blocks' of marks allowing the ink to run out slightly before recharging the brush. Practise some wet and dry marks together to give texture.

This image shows the correct hand and arm angle.

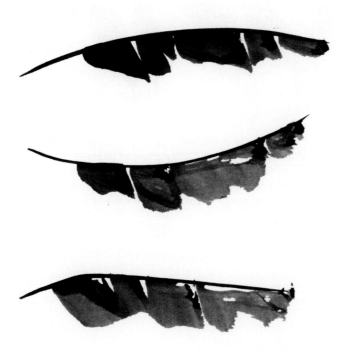

Banana leaf. These are the same marks drawn against a long, curved stem. This brushstroke is perfect for rendering tropical or broad-leaved plants.

## Two-Stage Leaf

### Round brush, pen hold
Leaf exercises in weak ink. These simple leaf
forms are drawn with one sweep of the brush.

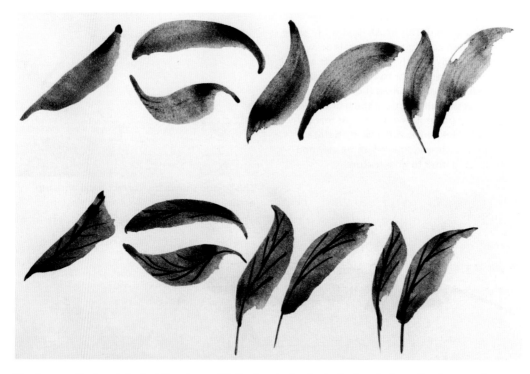

Top image: Start each leaf at the stem with the brush tip. Push the brush down firmly onto the
paper then smoothly lift it back up to complete the leaf at its tip. Fill a sheet of paper with these
brushstrokes. Now try lots of curled leaves at different angles. Finally, try starting at the tip of the
leaf and pulling the brushstroke towards you. Create lots of different leaf shapes and varied
textures too by allowing the ink to run drier. Bottom image: Rigger. These are the same leaves with
veins added later in darker ink.

As you draw more and more, you will become aware that your hand angles change subtly between the brushstrokes. Instead of 'pen hold' and 'vertical hold', the slant of your hand and brush may sometimes be somewhere in between the two. Similarly, your brushstrokes may now become something experienced rather than merely something drawn. Draw simple leaf forms regularly. It's a typical calligraphy stroke that you will find invaluable and can finesse with practice.

A two-stroke leaf. Round brush. Pen hold. Broad stroke: each brushstroke is rendered as the previous exercise. Fine lines: these are drawn with the tip of the rigger. A smooth arm action is needed to render these leaves. The white of the paper gives light to each leaf.

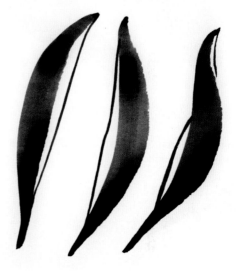

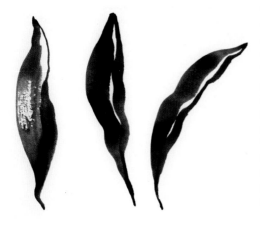

These brush marks are created by pushing the brush down intermittently as it moves across the paper. Change your hand angle too as you move through the brushstroke. The first of these three leaves has a lovely dry texture as the ink was running out. The second two slightly wrinkled leaves are drawn with a very wet brush which has caused 'backruns'. These may arise whenever a well-loaded brush is used, especially when two different ink strengths meet. They may appear randomly and should be welcomed, as they're a natural alchemy of the water with the ink.

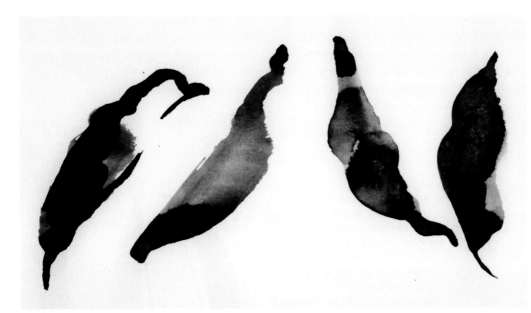

Some leaf variations, created by twisting and turning the brush as well as applying different pressures throughout.

**1**

This is a hand working detail of a wrinkled leaf shown in three stages: starting the leaf at the stem with the tip of the brush.

**2**

The broader, middle section of the leaf is achieved by pushing down onto the brush head.

**3**

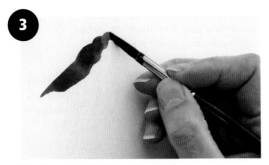

The brush tip finishes the stroke.

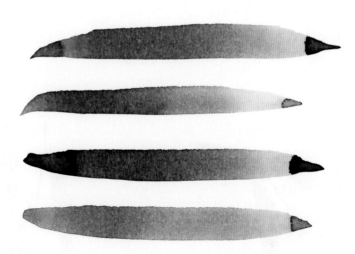

Willow leaves. Round brush. Side hold. Draw some long, horizontal leaf shapes in weak ink using the side hold.

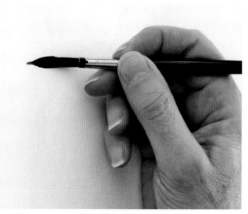

Both brush and line should be aligned and travel smoothly from left to right. This is the start of the brushstroke.

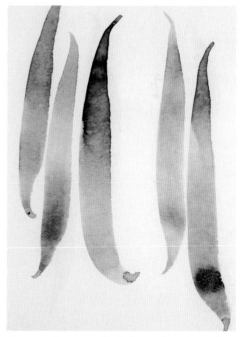

Now try the same leaf shapes but draw them vertically. Using the perpendicular hold, start at the top of the leaf and pull the brushstroke towards you. The start and finish of the brushstroke has a little curl.

## Willow leaf cluster

For this exercise you'll need both weak and strong ink. Pre-mix these in two separate pots.

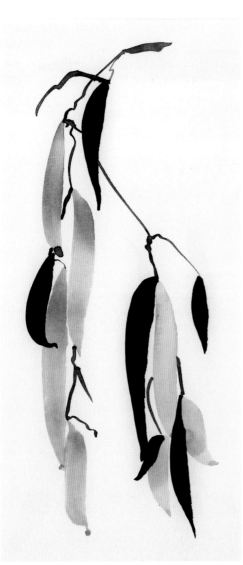

Explore your subject through lots of drawings. This leaf study is one of several that I drew from a tree in our village.

**This leaf cluster is drawn in two stages. First, draw the weak ink leaves and allow to dry. Note the space to add in the dark leaves. Add in the dark leaves. Finally, draw some fine branches with the rigger brush to complete the study.**

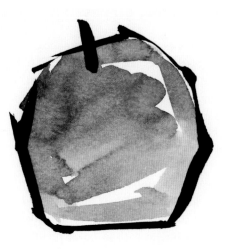

Apples. Round brush. Pen hold. There are many ways to draw simple forms like apples. This is a roughly drawn, outlined apple done in two stages. In strong ink, draw its outline using quick brushstrokes. When dry, draw the solid form of the apple in weak ink, working quickly and leaving some white paper to indicate light.

## Paper Behaviour

As you work with more ink on the paper surface, you will find that cartridge paper has a tendency to buckle or ripple slightly. This is where the wet ink has caused the paper to shrink slightly. When you have more experience, you may want to use heavier, better quality paper for more formal studies. 300gsm watercolour paper is perfect for this as it will distort less when wet, though even paper of this weight may ripple slightly if very wet.

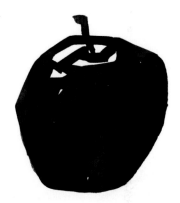

Try some solid apples in dark ink and work them fairly quickly. When you've got the hang of apples, draw pears and plums.

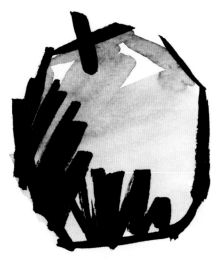

This apple has some added dark brush sweeps to give it a more three-dimensional feel.

Plum. Round brush. Vertical hold. Plums are a very similar shape to apples. Work them with one brushstroke, using only the tip of the brush. Start at the top, working anti-clockwise and finish its outline with a little curl. Add a dot for the stalk.

## Using Colour

When you've got the hang of black ink and its various tones, try one additional colour. If you are using weak ink of any colour, always pre-mix this in a clean bowl before you start working. Remember when using ink colours to rinse your brush well in clean water in between colours.

Small fruits such as cherries and grapes can be drawn very quickly. The shape of the light reflections on each fruit are subtly different.

## Cherries and grapes

This cherry exercise is done in pre-mixed red ink and black ink. Experiment with different strengths of your new colour from weak through to strong by adding different quantities of water. Complete a tonal bar exercise in red ink as you did earlier for black ink. This will get you acquainted with its tonal range.

**Round brush, pen hold**
This drawing was done from supermarket-bought cherries. I wanted to capture their dark, shiny quality. In a clean bowl, pre-mix some black ink and water to give a mid-tone. Put a little neat, red ink in another bowl. Practise drawing some fruit shapes in weak black ink till you get a feel for the shapes.

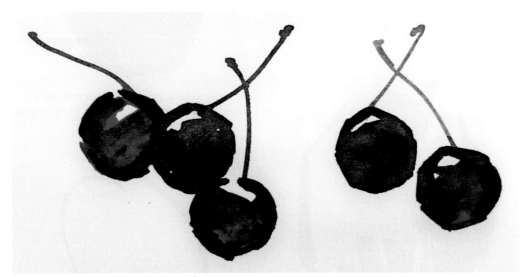

Draw some cherries in the stronger black ink mix, leaving plenty of white space within the fruit to add in red ink later. Allow to dry and rinse the brush thoroughly. Finally, add in the red ink. The remaining white spaces in the fruit are all slightly different and show how shiny the fruits are. When the ink is dry, use a rigger to draw the long stems at different angles. Try some outlined and solid cherries together.

**For coloured grapes:** mix some weak blue and pink ink together in a small bowl to attain a purple tint (*see* Chapter 2).

Grapes. These grapes were drawn while on the stem but I left the stem out of this drawing. After practising some brush curves, I drew these quickly using three or four brushstrokes for each fruit. Grapes have longer, curved reflections.

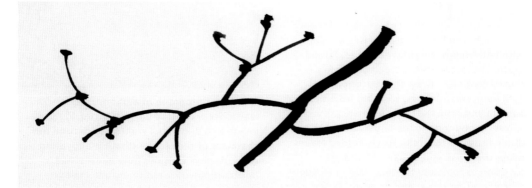

This is the stem, drawn with a rigger. Each little line is drawn with short, confident thrusts of the brush. Practise the fruit and the stems separately before putting them together. (Only a little bit of stem may be apparent when the fruit is attached.) Buy some grapes and draw your own version of this exercise.

Become more aware now of the pressure you are applying to the brush as it connects to the paper surface.

All plants have their own particularities of structure and growth. There are many kinds of lavender and they all smell wonderful! Keep a pot on your workbench for a while. Go foraging for a variety of plants to draw in the summer when there is an abundance. In the winter, have one or two good plant reference books and your own photos or sketches to work from.

**Phormium. The following exercises are done with both round and rigger brushes. Round brush. The large leaves spread out from a central root base. Draw the straight leaves with long, smooth lines, working from the base up and from the leaf tip down. Curved leaves: gently change the angle and pressure of the brush through the curve. Folded leaves: pause the brush mid-stroke and change direction to complete the leaf. Add in a couple of leaves using rigger and dark ink. Experiment with all these leaf shapes separately before you draw a whole plant as practice will lead to smoother brushstrokes.**

**Here's a photograph of a phormium. Several leaves were omitted when transferring the image to a drawing. I wanted to capture the character of the plant without it appearing too fussy. Always consider how much visual information you want to include in your studies when working from a photograph.**

Grasses. These grasses are drawn with the same brushstrokes as the phormium, using both round and rigger brushes. Create height and depth through brush length and line placement.

Lavender and corn. Round brush. Pen hold. These stems are drawn with the very tip of the round brush. The seed heads are rendered with pressed marks: gently pressing the brush head diagonally in rows. Each seed head sits against the stem. Other grains such as corn and wheat can be drawn using this technique. Return to practising some straight-line exercises if your stems are looking a bit wobbly.

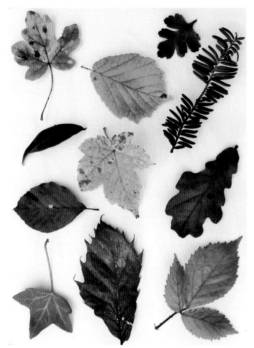

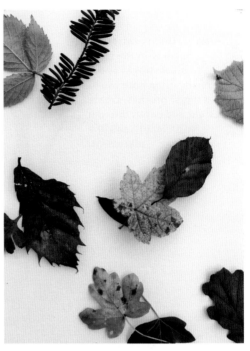

Leaf shapes. Leaves come in all shapes and sizes. Here are some I collected when out on a winter walk. Find at least six different leaf shapes of your own to work from.

Creating an aesthetic arrangement. On a sheet of A4 cartridge, move your selection of leaves around till you find some interesting overlays and dynamic spaces. It took a few minutes to find an arrangement I liked. The largest space here is as important as the arranged leaves.

Lay out three slightly different leaves and trace round the edge of each one in pencil.

Round brush. Now draw them out again. This time overdraw the right side of each leaf with the tip of the brush.

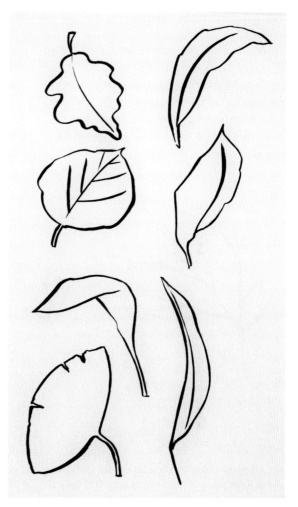

Here is variety of leaf shapes for you to try. They are all drawn freehand with the tip of the brush. Note all the different angles. Even in winter you can find leaves scattered about the woodland floor. Later, try some complex leaf shapes such as fig and maple.

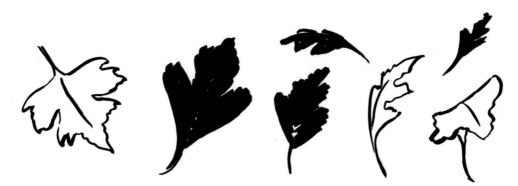

Chrysanthemum leaves. Chrysanthemum leaves have very decorative edges. Draw the outlines of these leaves in pencil. Round brush, pen hold. The solid leaf on the left: start at the base of the leaf, working from the centre vein outwards in close set diagonals till you get to the top. Now draw the right side of the leaf in the same way. The outlined leaves are drawn as previously.

## Twigs and branches

There are particular techniques for rendering flora and fauna in East Asian teaching. These brush types and methods often have historical precedents or terminologies. Such traditions have been carefully followed down the centuries and can be found in numerous new and republished books.

My preferred brush skills have emerged through tutelage, practice and experimenting along with my students. Out of these explorations have emerged the various brushes and brush holds for this book.

You are now getting used to holding the brush in a variety of ways and drawing lines in any direction.

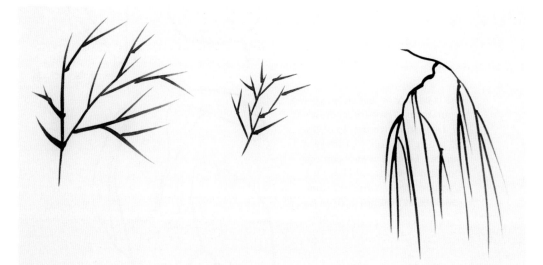

Round brush. The small shrub on the left and the branch in the middle are both drawn with short, sharp lines using a 'thrown' action. Use only the tip of the brush. This will give each branch and twig a lovely fine tip.

Rigger brush. The willow branch on the right has longer, trailing branches. Each long stem was rendered by pulling the brush from the top and then lifting it off the paper quickly at the end of each branch. These long, fine lines exactly describe the flowing branches of the tree.

## Old branch

As with all things in nature, you may come across many odd shapes. Among old oak and fruit trees is a good place to hunt for weather-worn wood.

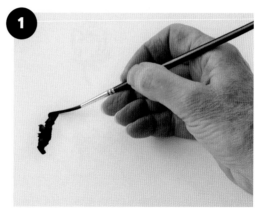

Start: detail of the top branch. Draw this from the bottom with the rigger held fairly flat to the paper. Nudge the brush left and right as you work up the paper to give the branch an aged look.

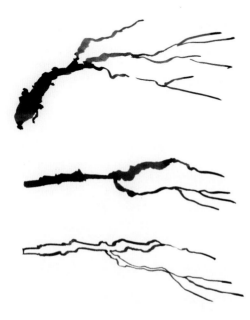

Top branch: rigger: this branch is old and weather worn and has nodules along its stem. New shoots emerge from this older wood. Middle branch: this is drawn with the same erratic hand movement as the top branch. Bottom branch: the same branch drawn in outline. All the new shoots are finished with quick, thrown lines.

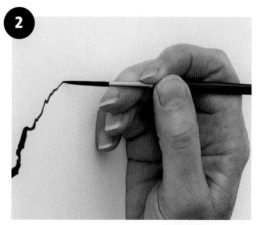

Finishing the top branch: as you draw, gradually lift the brush up so that it is nearly vertical when you get to the end of the twig. Add a few nodules here and there to further accentuate its age.

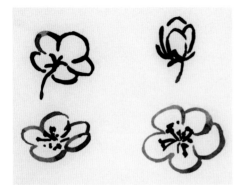

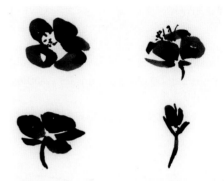

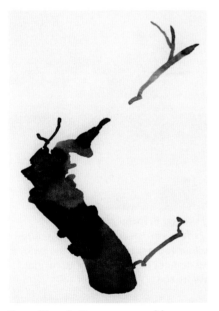

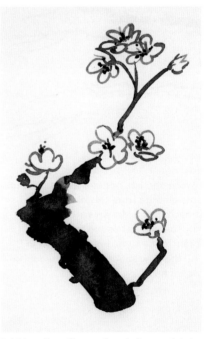

Plum blossom. Round brush. Vertical hold. Here are some plum blossoms drawn in outline using the very tip of the brush. Vertical hold is best as it renders fine lines and allows the hand to work smoothly through all the curves. Try the pen hold too for comparison. Add stamens and stems with the tip of the rigger.

The large flower petals are drawn by twisting the brush very slightly on the paper surface. The smaller petals are made with pressed marks. If you want a similar version of 'plum blossom', try apple or nectarine blossoms.

Round brush. Here are some blossoms on a stem of both old and new wood. Load the brush well with weak ink. Using the side hold, start at the bottom of the branch, placing the whole brush head flat against the paper and firmly push it away from you. Gradually lift the brush as you push it up the paper so that the brush angle changes slowly from 'flat' to vertical. Still using the vertical hold, draw in a couple of fine twigs. Repeat this exercise, leaving a gap to add in flower heads.

Add in a few flower heads in weak ink.

Find some fruit blossoms in the spring. You'll have a two- to three-week window for outside fruit trees. Draw these delicate flowers in both outlined and solid forms.

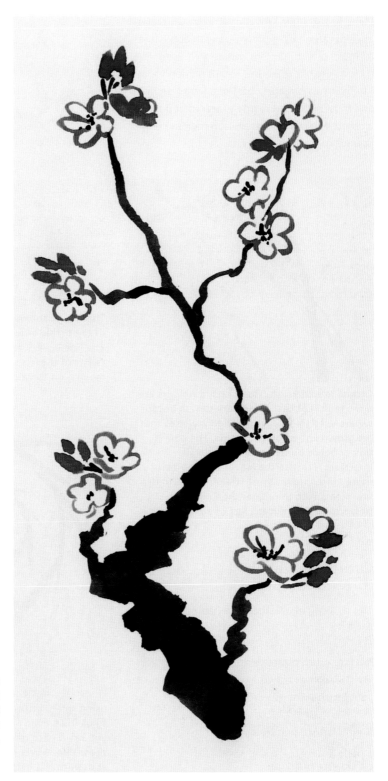

This study with pink ink added has both solid and outlined petals. Start with this image and then try your own version.

I tend to use apple blossoms as a drawing reference because I have grown up with apple trees in most of the gardens where I've lived. We have a very old apple tree in our garden today. I think it was originally part of a larger orchard and must be at least eighty years old. It puts on a grand display through the summer and crops pounds of cooking apples.

This image shows part of the top right corner of the orchid study. Each petal is worked with one line in very weak ink. Practise the subtle twists of these shapes on their own before moving on to whole flowers.

**Orchid. Round brush. These orchid flowers are more typical of East Asian varieties. In Britain, we are used to broader petalled varieties that are grown and displayed inside. The pale flower heads on this orchid face in all directions. Practise the leaves on their own using long, thrown brushstrokes. Draw in the fine stems with the rigger then add in the flowers. Do the stamens last of all in dark ink.**

## Catherine wheel

This drawing of a Catherine wheel captures the aesthetic of space perfectly. The flowing space in between the drawn lines is as important and holds as much presence as the lines themselves. Try the following two exercises to sharpen up your brush skills.

### Round brush, pen hold
This is excellent for quick mark making and confidence building.

**First exercise: Begin at the centre of the wheel using small, thrown lines, gradually working them in an even arc and increasing their size as you draw each one. Every line is started from the inside, working out. Draw a pencil curl to start with if it helps you to draw quickly.**

## ROUND THE CLOCK

The subtle directional changes that your hand must make for this 'round the clock' exercise are essential for accomplished drawing and will really improve your brush skills.

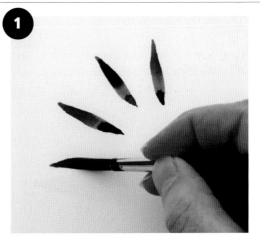

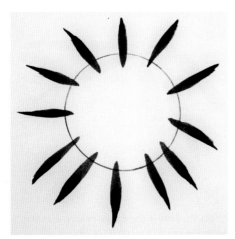

This second exercise is great for practising smooth brushstrokes worked in all directions. Each mark starts with just the tip of the brush, pressing down onto the paper to create the widest part of the line and gradually lifting the brush tip up again to complete it. This is a slightly more advanced exercise, as it is the hand and brush that must be adjusted and not the artist moving the paper.

Start at 'number 12' on the clock, working from the outside, in. Draw number 11, working anti-clockwise down the left side of the clock. The angle and travel of the brush must align exactly with the line you are drawing in order to render completely smooth edges. This is demonstrated using the side hold for the 9 o'clock position.

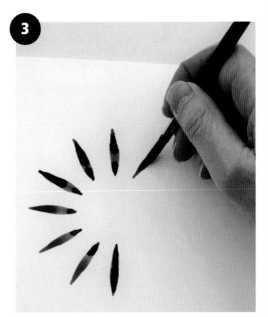

Continue working anti-clockwise towards 6 o'clock. Your hand hold and brush angle must change slightly for each 'number' on the clock.

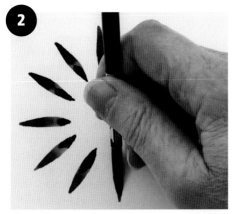

After you have drawn 6 o'clock, go to number '1' and work round clockwise for the last five brushstrokes. These are now drawn from the inside out.

## Drawing bamboo

The simple shape of a bamboo leaf is the visual and technical bridge between calligraphy and painting. Drawing it well requires a lot of discipline to start with because each leaf must have a perfect shape.

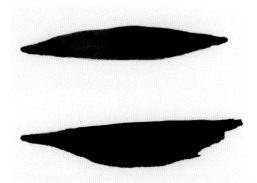

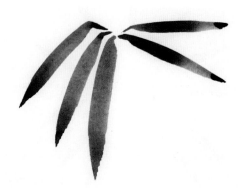

Round brush. Here is a reminder of the marks that a side hold and a pen hold will render: the upper mark was drawn using the side hold, working from left to right. This brush hold will render a smooth-edged line, top and bottom, when you are drawing a horizontal line. The lower mark was made with a pen hold and has a more broken edge along the bottom.

Round brush. This is the same exercise as the one below. Here, the marks are longer, denoting more mature leaves. A little detailing is added. Draw each of these leaves quickly with a short thrust of the arm. The three leaves on the left are started at the bottom of the leaf with a short turn added to complete the stroke at the top. The two right-hand leaves are started at the centre of the cluster, finishing at the tip.

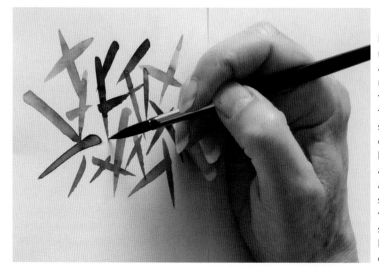

Bamboo leaves are rendered using both side and pen holds and lots of more subtle variations of these, somewhere between the two. This practice sketch shows a typical exercise before drawing bamboo leaves. The brush and hand angles are adjusted for each mark. Fill some cartridge paper with these experimental leaf shapes, from a wet, well-loaded brush through to drier, more textured marks.

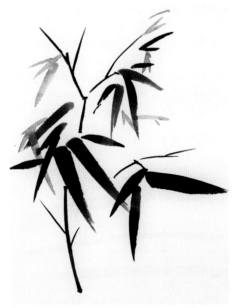

A completed drawing of stems and leaves together. Draw in the stems, leaving spaces to add in the leaf clusters later. Use both strong and weak ink and a variety of leaf sizes to bring it to life.

**Vertical hold. This young bamboo stem is drawn delicately to contrast well with the broad marks of the leaves. Only the tip of the brush is used. Tiny cross marks define the end of each bamboo section. Try this exercise with the rigger too, which will feel quite different from the round brush.**

Take some photographs of bamboo with back light as this will show the dark, dynamic shapes of its leaves and stems. (I climbed inside a huge plant to get some good photographs.) Explore some quality images of bamboo on the internet and experiment with some of the techniques you discover.

**This is a very natural-looking cluster of young leaves and stems photographed underneath a large bamboo canopy.**

Bamboo comes in all shapes and sizes. It is traditionally drawn from the bottom up but the drawing below was done horizontally as it is easier to start with. Load the brush well and drag off the excess on the inside of your ink pot.

Bamboo drawing requires much practice. It is a brushwork skill that you will always learn from.

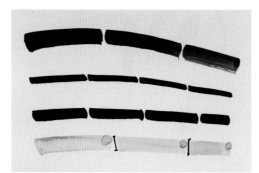

Older bamboo stems. Round brush. Using the perpendicular hold, press onto the brush so most of the hair is connecting to the paper. Drag the brush sideways for 5cm or so, giving the arm a good thrust. Leave a small space and draw another line for the next section of bamboo, and so on. Thinner stems can be drawn with less pressure applied to the brush, rendering a thinner line.

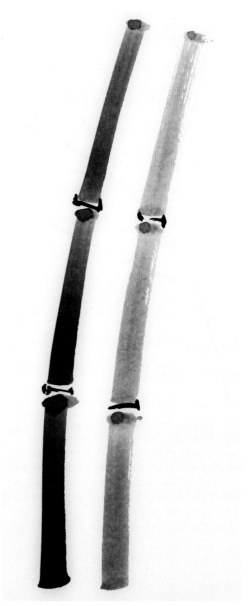

Side hold. Now try the stem worked vertically, starting at the bottom and dragging the brush upwards. Press down on the brush lightly at the top of each section of bamboo to create a tiny 'lip'. Leave a small space between the sections. Continue up the stem and allow the ink to dry out naturally as you travel upwards. These drier marks will give character to the drawing. Add a fine, dark line in between each bamboo section with the rigger. Each of these should be slightly different.

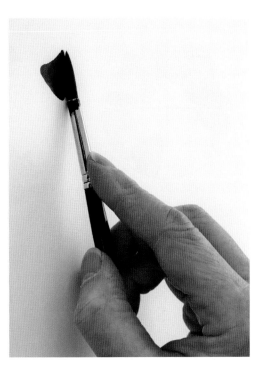

Poppy. Round brush. Soft petalled flower heads such as hollyhocks and poppies can be drawn using the 'twisted' brush technique. Hold your hand on top of the brush so the whole brush head lies flat on the paper. Pivot the base of the brush on the spot, which will enable the brush tip to twist in an arc, creating a ruffled outer edge to each petal.

This is a side view of some poppy heads using the twisted brush technique. They fill the space of a quarter circle. Each little flower is slightly different. Add a fine stem with the rigger.

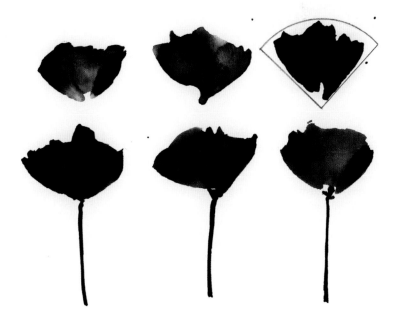

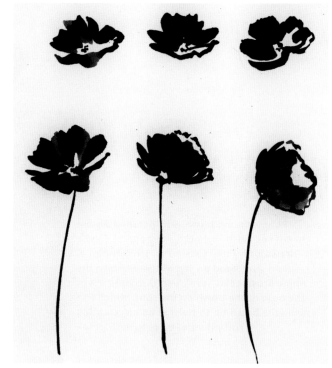

Experiment with lots of varied marks to create flower shapes. These poppy heads were generated with lots of movement from brush and hand.

Here's how to draw some lovely, ruffled flower heads. Draw a circle 55mm across in pencil. Quarter it. Draw out two more circles and again quarter them in pencil. Using weak ink, fill each quadrant with two or three twisted brush marks. Turn the paper round for each section to start with if it's easier. Leave some space at the centre of each flower. Complete all three flower heads and then finish them with a few dots with the rigger for pollen. The lower two flowers in this picture show two pollen patterns.

## WISTERIA

The wisteria, like so many plants in classical Chinese history, symbolizes many human traits. Its vine-like stems are very strong. Its delicate blossoms are fragrant and hang in soft trails. This coloured study of the plant shows two important things. First, the value of practice in perfecting your brush marks and line work. Second, the East Asian approach to creating a formal study by setting down all the components of the artwork in separate parts.

For exercises that have two or more stages, it is a good idea to have several studies on the go. Working on a few pieces in rotation is an excellent way of simply concentrating on a task. This gets you away from thinking of any thoughts of 'making a picture'.

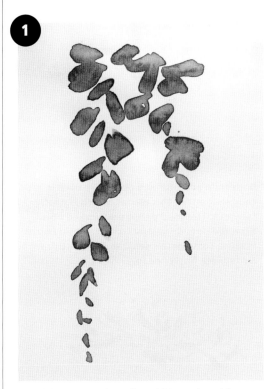

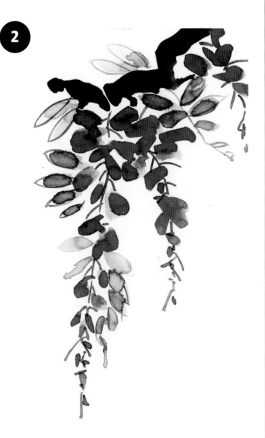

Mix a lilac tint with pink and blue inks. This blossom on a branch was worked in three stages.

Stage one: Round brush. The large wisteria florets are drawn with a combination of pressing and twisting. The small buds are simple, pressed marks. Use just the brush tip for the very smallest buds. Note all the spaces around the flower clusters to add in the stems later.

Stage two: The main branch is drawn above the flower clusters in very strong ink. Press the brush head nearly flat to the paper then drag it lightly across and up the paper surface, gently turning your hand anti-clockwise as you reach the top of the paper.

Stage three: Pressed marks. When the branch is dry, add in the large leaves using weak and medium tints. The fine outlines and small stems are done with the tip of the rigger.

## Chrysanthemum

Chrysanthemums are one of the four noble plants. Known for their fortitude, they bloom late in the season, tolerate the cold and are in flower for a long time. These qualities, along with their vibrant colours, are always uplifting on grey days. They are great plants to draw as they allow the artist to use a variety of florid brushstrokes.

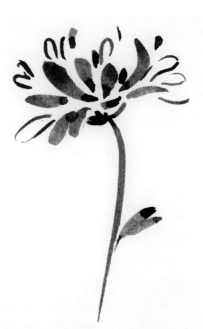

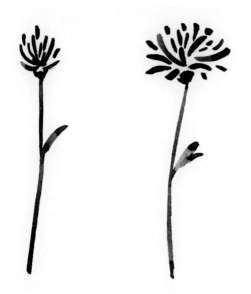

**Both solid and outlined petals are used in combination for this bloom, which is nearly fully out. The solid petals are worked both from the outside in, and from the inside out. Practise some petals separately before drawing a complete flower head.**

**Round brush. Bud and emergent petals: just the brush tip is used at an angle of about 60 degrees (part way between pen and vertical holds). The vertical brushstrokes are 'pulled' (worked from the top, down.) The horizontal marks are drawn from left to right. The arrangement of marks and the spaces around them will take a bit of practice as many petals have been omitted from the real flower head. Buy a potted plant to work from. It will be happy on your workbench for several weeks.**

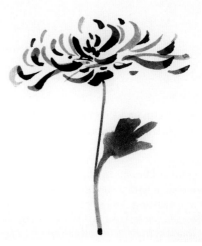

**Weak and medium strength inks were used for this mature bloom. Mature flowers have more of a curl to their petals. Draw all the petal shapes in with pencil and then cover them with brushstrokes. This will build both confidence and skill.**

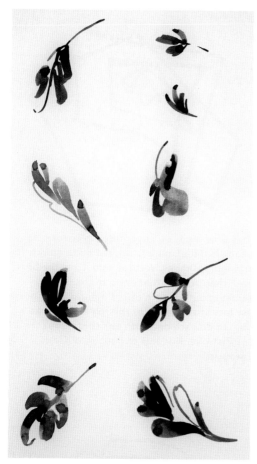

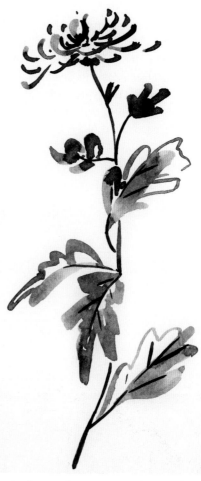

A cascade of chrysanthemum leaves of different sizes using both solid and outlined brush methods. The fewest amount of brushstrokes were used to give life to each leaf.

A single chrysanthemum stem that combines all the previous exercises.

# Rose

The English rose is an icon of the British garden. It blooms through summer, autumn and into early winter, is thorny but beautiful. Its fragrance is multifaceted and its dried petals make wonderful confetti. There are hundreds of classic and modern hybrid roses to choose from. Here are some different ways to draw them.

This drawing is of a hybrid tea-type rose; its shape is full of angles, worked quite quickly in triangular shapes. Vertical hold. Load the brush well then start at the centre of the flower, working outwards in offset triangular shapes. Try lots of variations of this exercise and be sure to do each one with one continuous brushstroke. Find lots of images to use as a resource.

This is a photograph of an old-fashioned rose. This variety has dozens of petals.

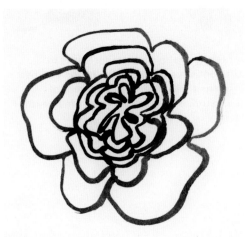

Lots of 'doodling' with the brush led to a line drawing based loosely on the photograph. Once again, it is drawn in a continuous line, working in loops and curls from the centre, outwards.

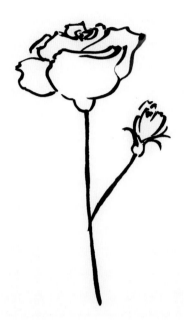

This is a side view of a thornless rose with just enough line work to give it character.

Foxglove. The foxglove has a delightful, architectural shape. It is drawn with the addition of weak, pink ink in both solid and outlined marks. This drawing has a strong emphasis on outline, which gives it a more illustrative feel. The thin spaces between the outline and the solid brush marks of both flowers and leaves have created a feeling of light through the whole plant.

The head of a ranunculus, drawn with abbreviated curves. This flower is a feast for the eyes as it has dozens of compacted petals. This drawing is more 'design' than descriptive. Peonies can be drawn in much the same way.

Try these flower heads with the tip of the round brush. Very little colour is needed to give them vitality. Take a good look at the pink tint to see how little is needed (the bottom brushwork in pale pink is all that was used for the flower above it). Less is always 'more'.

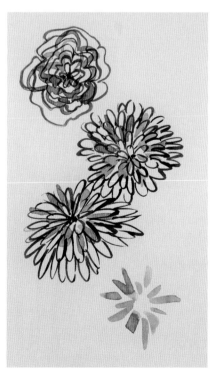

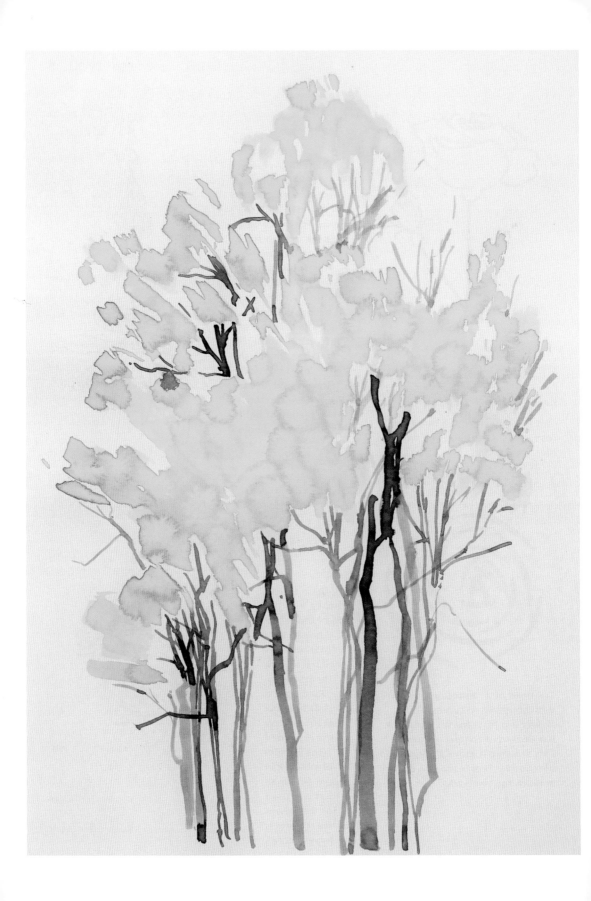

# 6 - Skill Building

The highest possible stage in moral culture is when we recognize that we ought to control our thoughts.

Charles Darwin,
*The Descent of Man*

Because brush drawing focuses primarily on activity, good drawing practice means generating a lot of sketches and not overthinking or worrying about what comes after this. A drawing may be useful or not. You may not know this till later. It is something made of its time. That's all that matters.

Focusing on one subject at a time will actively build a positive learning experience. Sometimes you may start with playful brush sketches before moving on to more formal exercises. Expect to complete a lot of drawings before you start any evaluation. Try not to switch around too much with your subject matter as it will scatter your concentration.

thought processes and cognition work can open up new avenues of perception; new ways of working.

Endeavour to keep your thinking periods separate from your drawing time. Tune into your 'inner child' who will readily connect to freedom and truth. Buddhist monks are said to have spent hours and days copying ancient scripts or drawing simple plant forms to discipline their mental activity. The quest was for a state of grace beyond thought.

Concentrating on simple brush exercises is totally absorbing. It is possible after some time spent with brush in hand to watch your own hand working without realizing it.

Slowly, you will determine when to think and when not to. Following the work of other artists keeps your hands busy, builds drawing skill and, very importantly, allows you to work freely because you are not emotionally attached to it.

## About Thinking

When I am drawing there is a sense of pure energy. Maybe it's chi but sometimes it's analytical thinking. Science has always sparked my curiosity. What neural pathways are buzzing when we think? How can we actively slow down an overactive mind? Understanding how

## Characterful Trees

Trees are the largest and most majestic of nature's rich tapestry. There are many fine ancient trees to be discovered around the British Isles. Perhaps you have some old, characterful trees like chestnut or yew near where you live. What forms do these trees take? How can you describe the distorted branches of an oak

**Left: Silver birch saplings. Strongly contrasting line work and foliage.**

tree or the trailing foliage of a willow? Your brush marks can answer these questions as they become more descriptive and flamboyant.

Drawing trees is a life's work if you wish it. So many stories and myths surround their evolution and our relationship to them. Tall, broad, ancient, elegant; all shapes and sizes fill our countryside. Many trees living in the UK may be several hundred years old. Many particular trees are now protected. Old trees will have survived insect attack, disease or carry the scars of weather damage. They may grow at odd angles as they seek out the light, so they hold many characteristics that can be captured through both disciplined and spontaneous brushwork.

The traditional trees that appear in artworks of the East include plum, pine and willow. All of these tree species grow in Britain. The pine, like the bamboo, symbolizes strength. The willow is graceful yet strong and will yield in any weather.

Without a doubt my favourite British trees are the yew, oak and sweet chestnut. Oak trees have always been important in British culture. The heartwood is very strong and was used to build houses and boats. It is still used in building and in the manufacture of modern furniture. Oak trees can be found in every native wood and hedgerow and can often be spotted standing alone at the centre of a field (see Chapter 1).

Find a fallen tree in a quiet woodland to just sit on and absorb the view. Become aware of the strong contrasts of light and dark around you. Take some photos to work from later. Try walking every day if possible. Whether cold, sun or rain, being in nature will help to generate 'good' hormones, endorphins. Absorb this natural environment world by osmosis. Start to really look at all that is around you and become aware of the seasons' ebb and flow. What does tree bark smell like when it's been raining? What does thick moss or leaf litter really feel like with bare feet? Allow the pure perception of your senses to arise.

White paper can be daunting for aspiring artists. It is only fear of disturbing it. Think of it as your arena, a place of possibilities where something dynamic can occur. Better still, watch any youngster with brush in hand and remind yourself of that freedom too. Take up some pencil sketching when you go out for a walk and this will encourage positivity.

Draw lots of deciduous trees in the winter to capture their structure and again in the summer when they show off their glorious foliage. Find

Wood grain drawing exercise. Draw this image out in pencil, using one line for each brushed line. This will give you a feeling for the shapes and form of this old tree trunk. Now do the drawing again, freehand. Next, draw it with your round brush, working each line from the top, down. Start the left-hand line with the brush tip, pushing the brush head down onto the paper to render a wider line. Finally, try this exercise again, working from the bottom, up. Go scavenging and find some of nature's textures of your own to explore and draw.

one old tree you like close to where you live and really get to know it.

The following tree shapes are fun ways to skill-build.

Conifers. Round brush. Pen hold. Here are some easy conifer tree shapes. Draw out some tall and short triangle shapes with a pencil. Start at the top of the tree with the tip of a well-loaded brush. Swing the brush from side to side as you travel down the triangle shape. Fill out the other triangle shapes you've drawn, allowing the ink to run drier to give your marks some texture. Add a short trunk to each tree.

Larch. This tall tree is also drawn with one continuous sweep, the brush here swinging diagonally at different angles. Finish on a horizontal stroke. Add a long trunk.

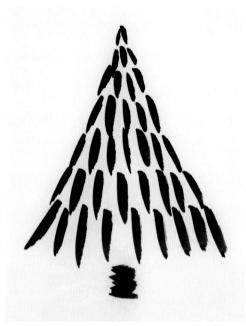

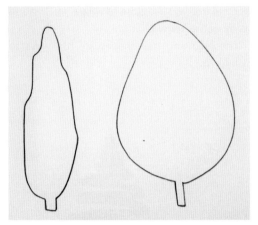

Here are two outlined tree shapes. The tall tree is typical of a poplar or cypress. The egg-shaped tree is typical of a small beech or holly. Draw them out in pencil.

Spruce. Here the brushstrokes are worked in vertical rows.

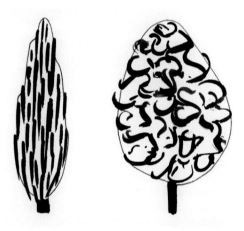

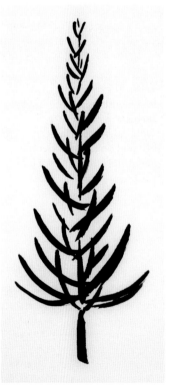

Pen hold. Fill the tall tree shape with vertical marks to indicate the steep angle of foliage or branches. Fill the second tree with a mix of curled brushstrokes to indicate summer foliage. Add a trunk to both.

Fir tree. Tall firs often have uplifting branches. This drawing is an abbreviated way of capturing this growth pattern. Vertical hold. Start this exercise by drawing a broken vertical line for the trunk. The branches are then drawn with a variety of quick, curved brushstrokes. Start with short diagonal marks at the top of the tree, working from the outside, in. Use more generous curves as you work down towards the base of the tree. Go back to the middle of the tree and add in a few vertical lines to give more depth.

Pen hold. This tree could describe a beech or young oak. The spaces between the brushstrokes and around the edge of the tree is more considered. Start with a wet brush and allow it to dry as you draw, giving texture. Try holding the brush three-quarters of the way up the shaft. This will give your marks more spontaneity. This drawing is A5 size so only my hand and wrist were moving. For larger drawings, more gestural movements involving the arm as well as the hand will be needed.

This is a great practice stroke to fill a page with. Round brush. Vertical hold. These brushstrokes are worked quickly in columns, starting at the top. Draw lots of curl shapes by rotating your wrist. Leave large gaps to start each column, then draw the curls with less spacing as you work downwards. When you've filled an A4 sheet, you will have drawn three or four columns and found a sense of playful rhythm.

**SPRUCE**

**Round brush, pen hold**

This spruce has downward-hanging branches with finer fronds hanging from these. Using only the tip of the brush, practise some branches on their own. Here are three single branch shapes to try:

First, draw one line for the main branch, then closely drawn lines for the hanging fronds. Then when you've finished practising the branches on their own, draw the tree, starting with a straight trunk. Again, work from the top down with fine brush marks, using only the tip of the brush. A few additional marks have been added to the centre of the tree to give more depth.

As with all tree species, the height, spread and general character of the tree will vary enormously.

Willow branches (brush practice). Rigger brush. Pen hold. Weeping willows are the most romantic of trees. They appear frequently in East Asian artwork. The sweep and flow of the long, trailing fronds are the perfect chi to capture. This is a practice exercise for a willow with long branches hanging downwards.

Main branches and trunks of willows are often wayward and full of character; this is always emphasized in classical paintings. Side hold. Rigger brush. The main stem is drawn from the bottom, up, with the brush pressed almost flat to the paper. Gradually lift the brush so that it is almost in the vertical position by the time it has reached the top. The long, trailing fronds must be drawn in smooth, calligraphic brushstrokes, which should be practised first. You may need to load the rigger several times as it holds less ink than the round brush. The base of the tree has a slightly gnarled, weatherworn appearance.

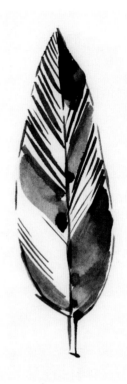

Herringbone exercise. Round brush. This is a great exercise for encouraging quick, repetitive brushstrokes. Try this 'herringbone' study in blocks, using both pulled and thrown brushstrokes. Draw one set with broad lines and the second set with just the tip of the brush.

As you gain more experience with the brush, you will become aware that your hold on the brush shaft will start to vary. How the brush feels and functions will become as important as the marks you make.

Feather. Round brush. The hold for this exercise is between 'pen' and 'vertical'. The hand and arm move as one to render these short, sharp lines. This feather is characterized with both brush tip lines and broader marks too, all drawn diagonally. Work from the top down, from the outside, in. Add a broken fine line around the edge of the feather and down the centre vein. These finer lines will give the feather a delicate feel. Leave a little white space too. Note the subtle shape from the tip of the feather to the curve at its base. Find some feathers to draw. Draw all their characteristics.

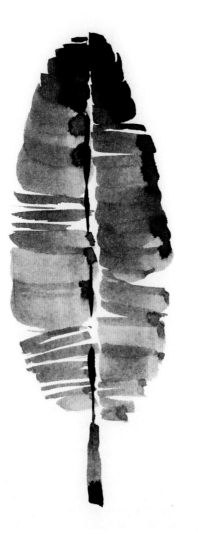

Banana leaf. Rigger. The shape of this leaf is slightly different from that of the feather, having a more rounded leaf tip. The small veins may be more perpendicular to the main vein, so they are drawn here horizontally. This leaf is not outlined but rather emphasizes a strong, central vein described with a dark, broken brushstroke. Next to this is an uneven line of white space, giving light.

Palm tree. Round or rigger. Dark ink. The leaves of tropical trees such as coconut palms all emerge from a central point at the top of the tree. This exercise is the perfect opportunity for the artist to experiment with a variety of brushes and hand holds. The branch shapes of brushed lines are exactly as covered previously. The branch shape is now 'up and over'. Try both dragged and finer, drawn lines to render palm leaves. The trunk is drawn in weak ink with one curved sweep of the brush.

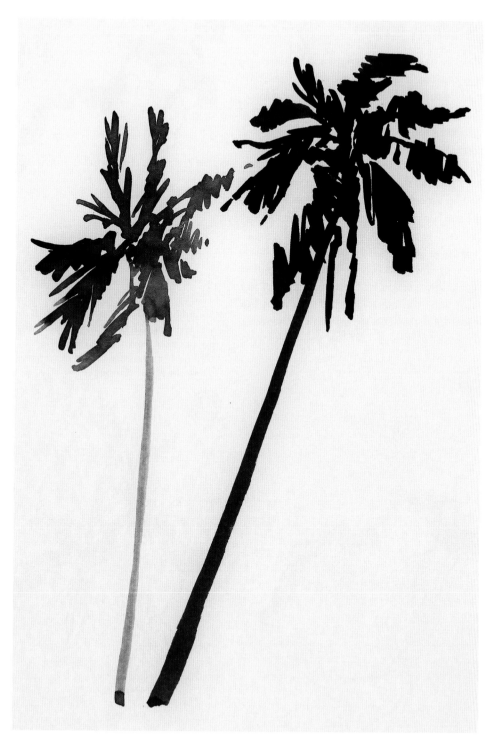

These two palms have a more weatherworn look, drawn quickly, without thought. Both dark and weak ink was used. Find some photographs of palm trees to follow and be more experimental.

## Scots pine branch

The pine tree signifies strength and hardiness as it is resilient to weather extremes. There are many distinctive pines in weird and wonderful shapes to be found in the countryside, often growing in small groups or in a row at a field edge. The pine tree's needle clusters and cones put on a year-round display. It is happy at altitude and can survive in little or no soil, instead finding a home in the thinnest crevices where the surrounding rock will give the tree support as it establishes itself.

This study shows in simple order the philosophy of line, space and form. The gnarled branch gives scope for twists and turns of the brush while the fine, trailing branches allow the rigger some play as they curve round the space beneath the branch. All the visual elements

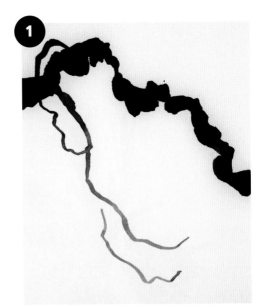

Round brush. Draw the main branch in strong ink, twisting the brush as you work diagonally up and then down, from left to right. The trailing branches are drawn in weaker ink, using the tip of the rigger.

Round brush. Draw the background needle clusters in weak, pre-mixed, green and blue ink.

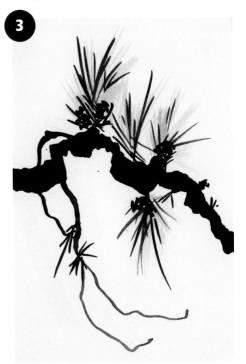

Add in the pine cones and other detailing with the rigger.

contribute to each other and display the tree's personality. Drawing the elements of branch, needles and cones separately will offer a greater appreciation of 'space' as something: a vital aesthetic held in balance with the form of the tree.

Three-way fir trees. Round brush. This fir tree sketch emerged out of some quick, experimental drawing. Note the intensity of the ink in the right tree and the drier, scratchy marks of the tree on the left.

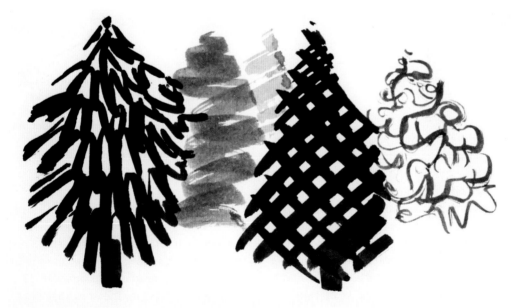

A fir tree group in a mix of wet and dry mark making and in weak and stronger inks. Change your brush holds for each tree. The possibilities of lines and marks are endless for this tree group idea. When you've drawn everything you can think of, come back the next day and you'll discover some more! Your brush drawing repertoire is now extending into new territory.

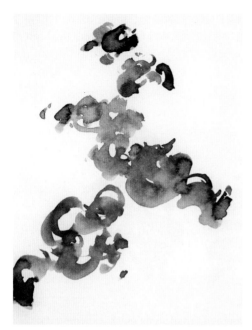

Foliage practice: round brush. Use quite a wet brush, dipping it first into weak black ink then immediately into weak green ink. Sweep the brush in small, vigorous curls. This drawing is one of several that I did.

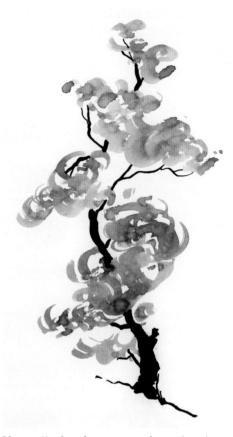

Rigger: Having drawn several practice pieces, this drawing was more intuitive with more space bouncing through the branches. A couple of branches and a trunk, all in neat ink, were added into the remaining spaces. This drawing fills a sheet of A4 paper.

## Weeping willow

The willow likes a watery habitat and is one of the first trees to burst into leaf in early spring. It is graceful, flowing and buoyant through the summer, offering a quiet, shady place with just the rustle of its leaves for company. This two-part study shown opposite shows well the contrasts of Yin and Yang through the energies of brushwork. Here, the trailing, summer foliage is displayed in broad swathes of leaves drawn with a very dry brush. As with the Scots pine, the brushstrokes must particularly describe the character of the tree. Drawing the willow in pencil will aid your brush skill too as the arm needs to sweep gently across the paper, whether with pencil or brush, to convey these many hanging branches.

## Repetition

The repetition of line patterns is a useful experience because it enables you to focus more on 'how' to draw, instead of thinking about 'why'. In East Asian philosophy the word 'repetition' is used to describe such simple tasks.

Within the context of drawing, repetition is a positive route to practical learning because a state of grace can be accessed. Repeating lines and marks is not done to 'improve' what you do. This will probably occur anyway. You are

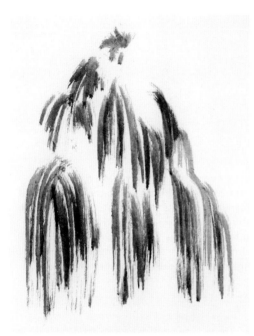

**Willow boughs. Round brush. Weak ink. The brush should be virtually dry. Once you've loaded it, squeeze all the ink back into the pot with your fingers. (Latex gloves are handy here.) Splay the brush head out by pulling the brush hairs away from each other at the brush tip. This will render 'feathery' marks. The foliage is then worked in pulled, straight lines that start with a subtle curve at the top of each brushstroke. Many practice lines may be needed here.**

**The willow's unruly branches can then be added into one or two of the spaces. It is important to incorporate strong, diagonal turns into the main stem which are so typical of the weeping willow. The dry brush (feathery) technique is great for many other trees that have hanging foliage such as weeping birch. It is also excellent for depicting vertical leaf growth such as poplar.**

more importantly 'experiencing through doing', in real time.

Repetition is a great tool that can lead to mental positivity and equilibrium because it is discreetly self-nurturing in the following ways:

- Repetition will still an overactive mind while allowing learning to occur.
- It is constantly affirming a 'new reality' as you work.
- Within Buddhist philosophy it can clear a pathway of unwanted thoughts because it enables the brain to focus on 'task' rather than emotions or desires.

- It will improve your hand/eye connection without an interfering cognition.
- It will build confidence.
- It can create long-term mental positivity because it allows us to 'step outside' ourselves.
- New perceptions are made possible by engaging with it.
- It can paradoxically lead to more intuitive ways of drawing that will emerge naturally.
- Over time it can dampen emotions as you engage with 'being in the moment' of drawing.
- It can be a truly transformational experience.

# Rules

The notion of 'rules' may seem a little at odds with the principles of this book but they can be very useful sometimes as they help to focus mind or activity. Repetition is just one way to re-programme yourself. Setting yourself some particular parameters or 'rules' can be very helpful too. For example, you could give yourself short timelines for particular drawing exercises to loosen them up. Try allowing long periods too on particular exercises, to pace your learning.

Music can also be a great contributor to drawing. Whether Chopin or club sounds, it will be sure to help you relax while you work. Have some plants or a poem or two in your work-space. This is your personal, creative arena where dynamic things can occur!

**Wherever you go, always take a camera or sketchbook with you. Photographs are a vital resource, particularly in winter. Even at home, the simplest of ideas present themselves through the lens. I was turning this chrysanthemum leaf over and noticed its shape against the wood grain of the pine table.**

# Evaluation

Much of this book encourages a non-thinking approach to brush drawing. However, evaluating your drawing skills from time to time will progress your learning and so requires some thought.

Put your drawings to one side for a day or two before you reflect on what you have done with a practical eye. It is always better to do this after a substantial period of working and not stop after every sketch with a verdict! Lay all your work out on the floor and have a good look at it. Write anything down as it occurs to you. Look at your drawings and check for line width, length and general quality. Have you used the correct pressure on the brush? This can mean the difference between a clumsy mark or a fine one. Are your long lines smooth throughout? Any unwanted glitches are usually caused by pausing part way through a brushstroke. Return to simple brush exercises that you need to practise. Some common drawing problems are:

- There is too much or too little ink on your brush. If too wet, remember to drag the end of the brush against the inside of the ink pot to release the excess. If you want really dry brush marks, you may need to squeeze out all the ink back into the pot with your fingers. Latex gloves are handy here.
- Are your lines too wobbly or uneven? Try drawing more quickly. Think of your arm as a sword thrust while drawing the line. Repeat the same line till it is smoother.
- Is there a lack of finesse in the drawn line? Try checking your brush hold and the angle of your hand as you draw.

The simplest exercise that is often the most problematic is that of the bamboo leaf. The brush hold and how it is used is integral to rendering the smooth, even line of this leaf shape. Return to the 'round the clock' and Catherine wheel exercises for practice.

**If your leaf shapes are too thin:** Push the brush further down onto the paper surface to render a broader mark. If the marks are too wide, less pressure on the brush is needed. For very fine leaves, only the tip of the brush should connect

to the paper. Return to the line exercises in Chapter 4 that you think may be helpful. They will remind you not only how to render specific lines but how the brush feels in the hand as you are drawing.

**Curled leaf shapes:** If your leaf shapes are too angular when you want them to be more curved, maybe the pressure you're applying to the brush is too erratic. Work the line with a flowing hand action. Perhaps the angle of your brush or hand needs adjustment. Curled leaves require a subtle transference of pressure on the brush while you are drawing. Practise lots of different leaf shapes, which will help you identify any problems.

Keep coloured inks for later on in a working period as they can be distracting. As a general rule, use only one or two colours. Black ink is always the essence of drawing.

Over time your 'set' exercises will become less formal and more expressive. You are finding your own visual vocabulary.

Paper quality will always affect your drawing results. Ink on cartridge paper dries very quickly and the paper may buckle slightly when wet, but it is the perfect paper for practice work. Newsprint is even cheaper to buy but is only suitable for early warm-up exercises. Hot-pressed watercolour paper is perfect for formal work as it is sized (with a gum Arabic sealant). This helps the ink to dry more slowly than on cartridge paper and therefore gives you a little more time to work. Some budget art suppliers may title their papers 'watercolour' or 'cartridge', but artists should test their quality for themselves. Experience will be your guide.

Any working period should include: brush play, skills practice (exercises), and then some time on your selected subject matter. Some days it's impossible to clear your head at all! Let the brush marks fall off the end of your hand as they will and leave decisions for another day. Sometimes some general reflection is what you need without any concrete decision-making.

While pursuing the perfect drawing, there will often emerge that most frequent of visitors to the artist's world: 'over egging it', the opposite of 'space'. You will always know when this is as you will have discovered it too late! It takes time to learn new methodologies so don't be overcritical. The general motto of ink and brush is 'if in doubt, leave it out'. Be minimal, not maximus!

Visit galleries and museums and really look at the painting or drawing in front of you. Does the brush have vitality? Find brush skills and subjects that appeal to you and allow them to feed into your drawing experience. Many oil painting brushstrokes used by Goya and Rembrandt are transferable to ink. Perhaps a John Piper painting, some Van Gogh ink sketches or some flamboyant Japanese calligraphy will strike a chord. Look online too for inspiration. The brush skills of noted artists is a gateway to an objective rather than subjective way of working.

Spend some time getting the feel of your subject matter with pencil sketches. Observational drawing will benefit both mind and hand. You may have only one 'useful' drawing. It doesn't matter. At the end of a drawing period, you will find that the hours have evaporated along with any desire for a sense of accomplishment. Discovering what hasn't worked can become a very positive experience.

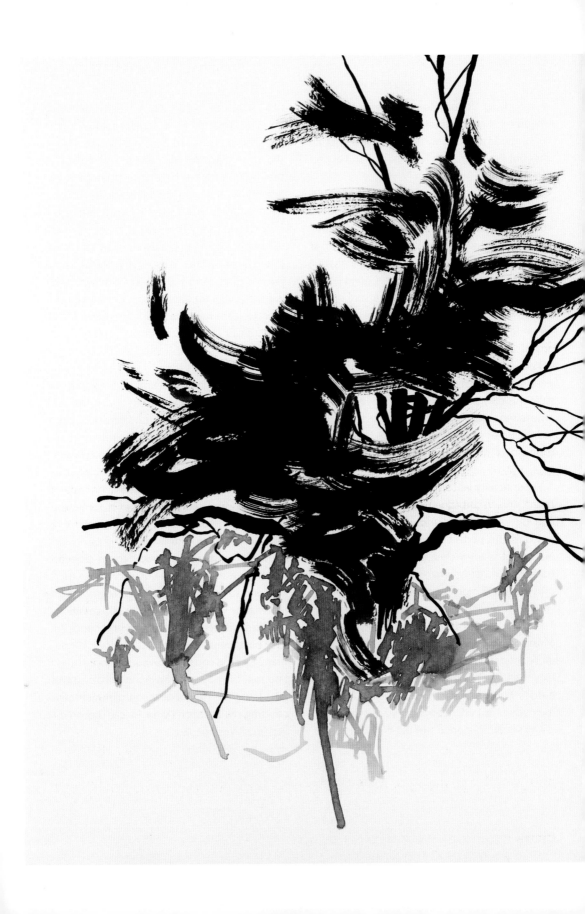

# 7 - Bold Landscapes

## European 'Space' Within the Landscape – About Light

Britain's most important artist, J.M.W. Turner, master of both oil and watercolour, brought the key subject of light to the fore. Long before the fashionable influences from the East started to take hold in Europe, Turner was transforming his landscape subject matter from 'something visual' into something more ethereal, an almost religious experience. Light fills more and more of his later canvases as his subject matter is subsumed into bright, painted brushstrokes. The Impressionists painters, those great conjurors of light, followed in his footsteps. In Turner's watercolours the eye is drawn to the quality of his delicate, bold brushstrokes that render the landscape with economic flourish. His formal paintings, too, are a dynamic display of nature's raw energies described with paint and brush.

Traditional European paintings of landscapes are usually in 'landscape' format: the longest sides of the painting are top and bottom, the shortest being the sides. The compositional construct or 'rule of thirds' was, and remains, a central idea to enhance the point of focus in a painting. Typically, two thirds of a painting will be sky and one third will be land (or the other way round.) This 'rule of thirds' can be further dramatized if it is stretched to three-quarters/a quarter (huge clouds above low-set land), etc.

This chapter includes images in both horizontal and vertical formats.

## Stretching Your Mind as Well as Your Body

The awe of standing before a big landscape can be a bit like staring at a white page! For those of you who feel daunted by an unending vista, a viewfinder is versatile and handy. This is a piece of card that acts as a 'camera frame'. Point it at areas of interest. Hold it close to your eyes then slowly move it away from your face to give you a tighter view in the frame. If you haven't tried one before, you may find it helpful.

Every panorama, whether of fields, hedgerows and trees or of a pale sea under dark rain clouds, offers exciting opportunities for the artist. A rocky shoreline can be quite dramatic, displaying both the dark shapes of the shadows and the light from the sun, yet the water's edge may disappear completely. Look at the view before you. What catches your eye?

Find a 'big sky' view from the top of a hill and you can get a sense of the immensity of clouds as they travel on the wind. What are their

**Left: Yew tree and ferns in winter. Strong brushwork can energize the space that surrounds it.**

**Viewfinder in card. The outside measurements should be approximately 21 x 15cm and the interior window should be 5 x 4cm. Use it horizontally or vertically depending on the view you want to capture.**

shapes as they bring in rain or disappear over a distant horizon? Look directly above your head at the shape and form of big clouds, taking in their huge volume. Perhaps in the distance there is a rain front coming in. Maybe there's a bright sunset filling a darker sky. Here is chi in all its guises, always awe-inspiring.

Perspective will show you that distant clouds are often very thin and lacking definition, dramatically different to the clouds above your head. Perspective can be very useful sometimes. At other times it can be less important to the artist than how you want the brush to find expression.

Seasonal weather will change your landscape view. A good way to capture fabulous skies that you come across unexpectedly is to photograph them. You'll then have lots to work from in your workspace on cold winter days.

Stand near the bottom of a high cliff or rock face to get a feel for its height and immensity. How many layers of rock strata can you see? How many millions of years ago were they formed and pushed around by the earth's great energies? It is difficult not to feel the wonderment of the natural world in places like these. Make the most of these views if you are away on holiday as you may not visit them again.

There are downlands and woods near me, calling me to walk or to draw. Perhaps you are already well acquainted with the countryside around you but have never explored it with pencil and sketchbook. Try being out in wet, windy weather as Turner is said to have done, so you can really feel it on your skin.

When you're out sketching, look for contrasting tones of dark and light. Allow shapes and lines to emerge from your pencil or brush.

Time spent on landscape drawing will challenge any preconceptions you may have had as to what is achievable. It will always be 'the big out there' but its energies can be captured by you, the artist, in your own unique way.

You can work in the landscape, 'en plein air' or in your workspace. If outside, a small camping stool is very comfortable and easy to carry. When in your drawing space at home, keep enough reference material to enable you to work freely.

# Introducing the Wash Brush

One does not discover new lands without consenting to lose sight of the shore for a very long time.

André Gide

**Side hold. This is the wash brush creating a broad stroke with a well-loaded brush.**

The previous exercises focused on drawing plants and trees with care and concentration. Some of the philosophies from China and Japan have been explored through these earlier exercises. I hope you've discovered that your brush and mental focus are beginning to find a harmonious place.

Ideas from East and West are now swept into generous brushstrokes, a synergy to describe landscape, sea and clouds. Perspective is only subtly conveyed.

Your third brush is a large, flat 'wash brush'. Traditionally it is used for creating washes but it can be used for 'drier' work too.

Choose a wash brush made of real hair as it behaves more gently on the paper surface than synthetic hair. The wash brush will deliver a huge range of marks and completes the range of techniques that will empower you to draw anything. Many of the following brushstrokes are the same as those already demonstrated. The only difference is the size of the brush and the more generous movements required of the arm and body.

A No. 30, flat wash brush is 3cm across the base. It is great for landscapes as it renders dynamic subject matter with flourish. It can also hold a lot of ink so can dispense broad, wet marks through to drier, more textured ones with just one brushstroke. You'll become acquainted with the different facets of the brush: on its broad side; using only one corner; or just the very tip to create stippled marks. As with the other two brushes you've been using,

it need not be expensive. I've had some of my wash brushes for many years. They're like old friends.

Many of the brush holds for this brush are the same as used previously. For some of these exercises, there may be no hand hold given, leaving it to you to explore the drawn line with nuance. This may involve moving both hand and arm. Once you've settled into a few basic techniques, it's just practice and a little courage that will enable you to render these more gestural marks with conviction. Spend some time pushing the brush around on paper till you feel relaxed. Many exciting new ways to draw may be discovered while simply playing with brush and ink.

We start with some straight-line exercises to describe a tranquil sea. Then curved brushstrokes are added to create cloudscapes. Finally, other brushes are brought in for contrast. These are all you now need to draw more extensive subject matter.

Consider nature's pure energy and how this can be transmitted by you through lines and marks of ink onto the paper before you. Gather up that inner vitality that is you to explore the unending possibilities of the brush-drawn line through some bold landscape drawing.

## Wash brush warm-up

### Wash brush, medium strength ink

Load the brush then drain the excess ink back into the pot by pulling the brush gently against the top inside edge. Explore all the facets of the brush, drawing broad sweeps and curves and odd-shaped stippled marks too. Use it on its side, its corner tip and the broad side of the brush, pulling it flat across the paper. Fill a second sheet of paper without reloading the brush to create some drier, textured marks. Flip your hand over the top of the brush and draw some more marks from right to left. Try both pulled and thrown brushstrokes. Finally, settle down to some smooth, straight brushstrokes. Cover lots of sheets of cheap paper till you feel at home with your new brush.

**Newsprint paper.** Fill an A4 sheet with some straight, horizontal lines using the broad side of the brush. A well-loaded brush may cause some backruns to begin with.

**Cartridge paper.** Reload the brush. Now try flipping your hand over and working a few rows from right to left. Right-handed people may find this tricky and will not be able to fully see what they are doing. Be bold!

Fill a sheet or two till your arm finds a rhythm. Think now about ink strengths and experiment with a range of grey tones, using weak, medium and strong ink mixes.

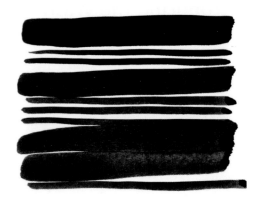

Side hold. This straight-line exercise is a mix of broad and fine brushstrokes drawn one under another using the two facets of the brush.

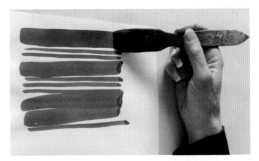

The shape of the brush will guide your hold on it. The broad stroke is rendered by placing the brush nearly flat to the paper and pulling it sideways with a smooth arm action. Any wobbles or uneven spacing will disappear with practice.

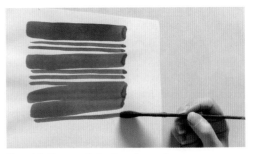

The side facet of the brush renders a narrow line and should also be drawn with a smooth arm action. Fingers and thumb fit neatly into the curved brush shape. The brush angle here is around 30 degrees.

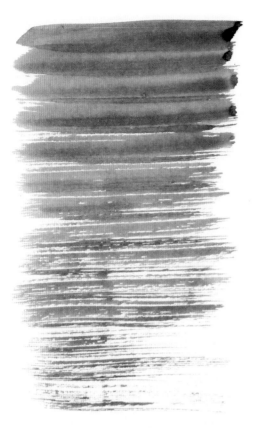

Weak ink. Load the brush, then squeeze most of the ink back into the pot. Draw a variety of broad, dry marks, pressing the broad side of the brush very flat to the paper and pulling it lightly over the surface. A very subtle pressure onto the brush is needed to create these varied marks. Practise till you have some dry, uneven horizontal lines. Now do several separate drawings on A4 cartridge. Keep one sketch for reference.

Cartridge paper. This exercise was done with a semi-loaded brush. (Some ink was released back to the pot.) Draw from the top down. Note the different texture of the ink as the brush starts to dry out. For very dry brushwork at any time, just squeeze the ink back into the pot with your fingers once you've loaded the brush. Try out the brush on a piece of scrap paper to test for the right 'dryness'.

When these are all dry, overdraw at least two of these sketches, again using a variety of broad, dry marks, this time using slightly stronger ink. This second layer of ink should now convey a tranquil sea. If necessary, dampen your brush on a kitchen towel to give your marks texture.

Compare all your sketches for texture and depth. Experiment some more with this technique and you'll become aware of the lightness of touch required to create these delicate marks.

## Cloudscapes

How can you describe the shape of clouds? What weather fronts are defining their pace and form? These boldest shapes of nature are water, air, energy and form, all at once. Huge, delicate, swift, dense. No adjective seems descriptive enough. Take notes of everything going on around you while you admire them. My favourite places for cloud-spotting are the Orkney Islands and the Sussex coast, where I live.

The National Gallery and the Clore Gallery (Tate Britain), both in central London, are good places to go hunting for inspiring cloudscapes.

You will need to work outside with pencil and sketchbook to gain some sense of the immensity and volume of clouds, their size and brightness. Rainclouds can be very dark indeed but often develop with much brightness around them.

This simple drawing defines the bold shapes of some rain-filled clouds. The rain coming in has dissolved the horizon line. In just a few minutes the view had completely changed.

Gestural arm movements can render more delicate marks too. In this exercise a light touch on the brush is needed to describe soft wind-blown clouds. Soft, subtle curves and straight lines are combined here in this dry brush sketch: just enough to describe light cloud over a tranquil sea. This study is worked in two stages.

When you have completed a range of drawings in one period, remember to leave them for a day or two before you evaluate them.

A pencil sketch gives you the opportunity to quickly take down the different light quality of cloud formations. Feel free to use strong pencil outlines when you are drawing a subject you are not used to. It helps to define the shapes of your subject boldly and clearly both on the paper and in your mind.

This exercise will embolden your mark making. The wash brush is perfect for drawing dramatic clouds and seascapes in the manner of Turner. These gestural marks come from the arm and not the hand.

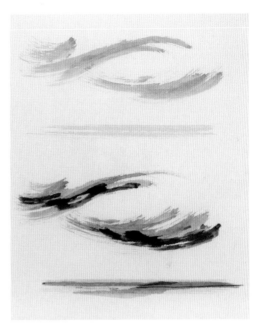

Hold your hand on top of the brush so that it is nearly flat to the paper. Using weak ink and dry brush, practise lots of these shapes on newsprint before moving on to cartridge. Experiment with various brush holds and allow the arm to move freely away from the body.

A3 cartridge paper. Stage one: Draw the top image in weak, dry brush and then repeat it underneath. Stage two: Add just a few additional marks in darker ink to the lower image to describe darker clouds. This exercise took a lot of practice to get my curves just where I wanted them and with just the right amount of ink.

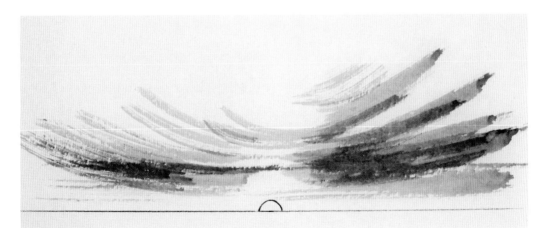

Sunset. Dry brush curves are worked from the top in weak ink, gradually stretching out to straight lines at the horizon. A few additional brushstrokes were added in slightly darker ink. The setting sun, drawn in pencil, is the point of focus. The sweep of the brush gently 'points' to the sun. The white paper at the top of the study and above the horizon are an important aesthetic which declare subtle light as 'something'.

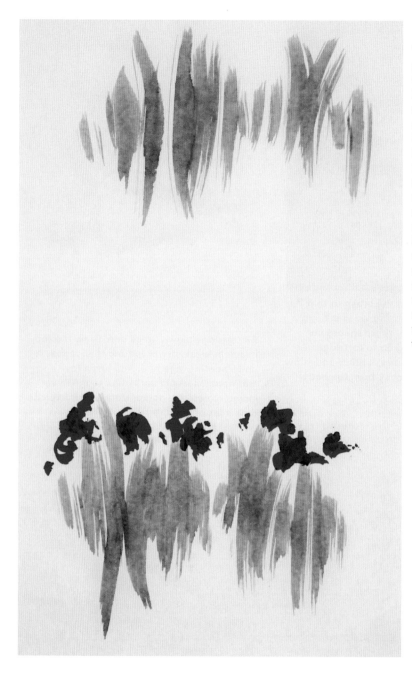

These foreground grasses are worked with the corner of the brush in quick, short sweeps. The length and spacing of the brushstrokes is irregular and the brush is almost dry. Splay out the hairs at the tip of the brush to create these 'feathery' marks. Rinse your brush in clean water and squeeze out some of the moisture. Now add some poppies in neat, red ink by making little twists with just the corner of the brush.

# Mixing Up Your Brush Selection

The following studies combine earlier brush skills. I had a range of photos and pencil sketches to help me work through some ideas.

**RIGGER: REEDS AS A FOREGROUND FOCUS**

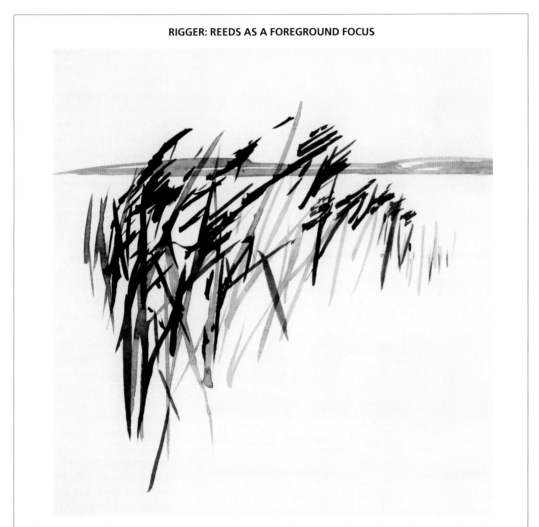

These reeds are drawn in two stages.

**Stage one:** Round brush. Weak ink. Draw in the distant shore. Rigger: weak ink. Draw a few random lines in weak ink using thrown brushstrokes. Work diagonally up the paper.

**Stage two:** Rigger. Dark ink. The seed heads are rendered in quick parallel, diagonals using a well-loaded brush. Only a few additional marks are added to hint at the stems in this blustery scene.

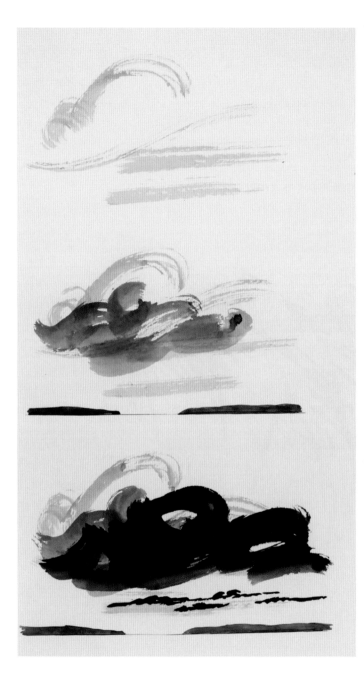

### Three-stage cloudscape

The huge cloudscapes and generous brushstrokes of John Constable inspired this next three-stage exercise that describes changing weather conditions. For this exercise I used A3 paper, cut into four strips across the sheet. Each of these three studies starts with the one at the top. Mix up three strengths of ink in three clean pots, checking the ink tones before you start drawing.

Light cloud on a bright day Stage one (top). Wash brush and very weak ink. The nearly dry wash brush has been 'feathered' at the tip to create these very light marks. Only four drawn lines form the basis of this first study. Repeat this first drawing twice more.

### Cloudy, bright day

Stage two (middle). Wash and round brushes using mid-strength ink. Draw in a horizon line then add in the distant islands with the round brush. Wash brush. Draw some darker clouds on top of the first exercise (I used five sweeps of a semi-wet brush).

### Rain filled clouds

Stage three (bottom). Wash brush and dark ink. This stage is worked on top of the first two stages. Use the whole width of the broad side of the brush to render these rain-filled clouds. Backruns may occur but will add to the feeling of drama. Round brush. Add in the islands again. The thin, distant clouds are described with dark ink, using only the tip of the brush.

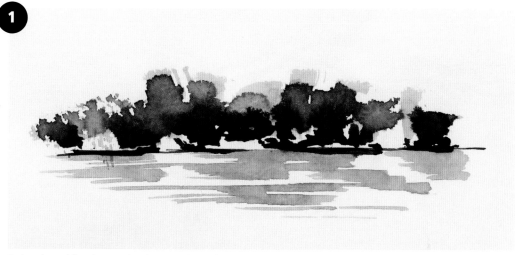

A developed landscape: background and foreground Interest using three different brushes. A5 paper.

**Stage one:** Round brush. Two-tone trees at the water's edge. Draw some very light brush marks for the background trees. When these are dry, add in some very dark ink with a wet, well-loaded brush. The thin spaces between the trees convey back lighting and those in the water are reflections.

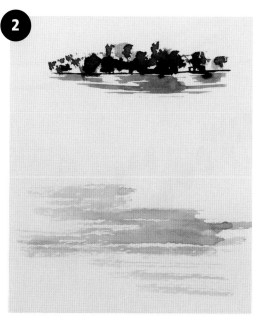

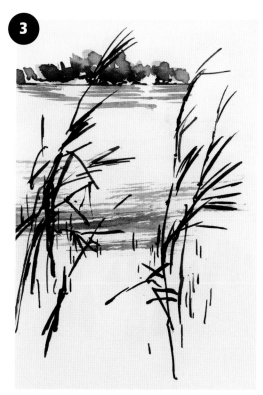

**Stage two:** Wash brush. Dry marks using a feathered wash brush are added half way down the paper.

**Stage three:** Rigger. Some leggy reeds are added left and right, creating some light through the centre of the drawing. Tiny vertical lines drawn with the tip of the rigger indicate new shoots emerging from the water.

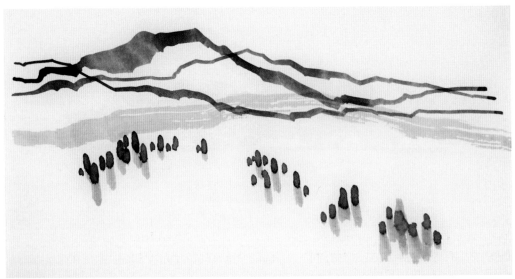

Scene one: Weak and medium inks. Rigger and round. The rigger is well-loaded with ink for the top three lines. Lift the brush up and down, rendering a mix of broad and fine line as you pull it across the paper. Round brush. The bottom, drier line has been dragged, using weak ink. For the fir trees: the whole tip of the round is pressed onto the paper.

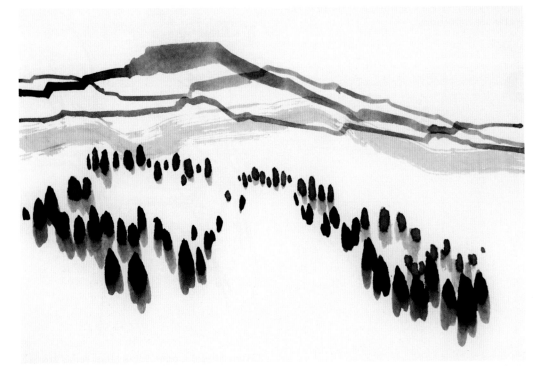

Scene two: As for scene one but I allowed some of the drawn lines of the mountains to create their own shapes. In addition, some larger foreground pines have been drawn in with stronger ink, giving more depth. The largest trees are rendered with two or three brush marks tightly pressed together.

## The same, but different

I was experimenting with the rigger brush, pulling lines across the paper, when mountains appeared! So here they are (opposite) as snow scenes. I wanted to see how few lines could be used to describe this scene.

## Scots pine clump

### Wash brush, mid-strength ink

Fill a sheet of A4 cartridge paper with lots of quick marks like those at the top of the image, using only the side facet and corner of the brush. Twist and turn it as you travel across the paper surface.

As you begin to master your brush marks,

you'll realize that every size and shape of brush can be employed in the same way; only the size of the marks will change. Mastering three brushes will enable you to draw anything that appeals to you in nature, using these same, simple techniques. You have now entered the realm of calligraphy where marks and lines are rendered with a dextrous hand to describe any subject matter. It is a combination of these 'lean' lines and your unique brush skill that in time combines and allows you, the artist, a place to 'be'. Drawing is a pure craft that can enable you to harness the profundity of East Asian philosophy. Sometimes these skills can be 'found' or, as I have more frequently discovered, 'earnt' through determination and brush practice.

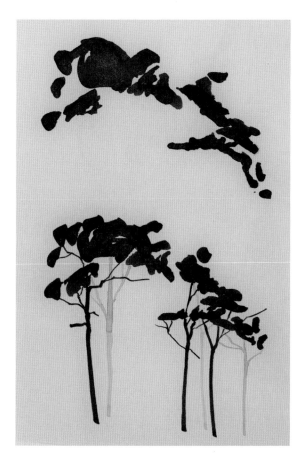

**At the top of a new sheet of A4 cartridge paper, make some small, light sweeps of the wash brush to convey the tops of this clump of pines. The marks on the right side are slightly lower than those on the left. Gently twist and turn your hand as you travel diagonally down the paper, using mainly the corner of the brush head. Repeat this exercise underneath the first one. Add a few tall trunks and branches with the rigger brush, using both dark and light tints. Don't let your conscious mind make the branches too tidy!**

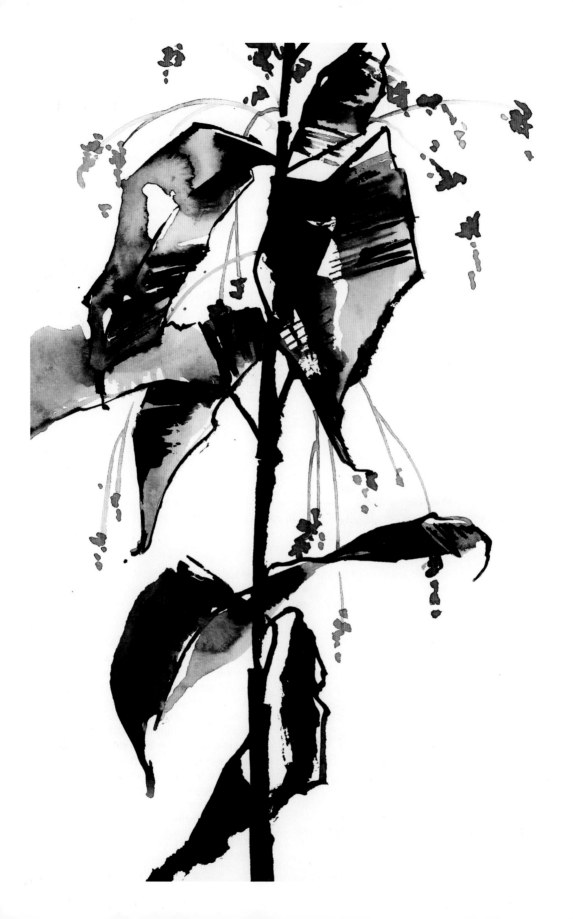

# 8 - Intuitive Working

...'The river can not go back.

Nobody can go back.

To go back is impossible in existence.

The river needs to take the risk

of entering the ocean

because only then will fear disappear.

because that's where the river will know

it's not about disappearing into the ocean

but of becoming the ocean.

Kahlil Gibran

Over time, you'll notice how certain brush marks start to assimilate with you personally. The subtle variations in your use of just one brush can produce a whole vocabulary of marks that are becoming your own unique language. Your drawing is now becoming more intuitive. Some particular techniques may stick for a while, some may be discarded. It may take time to find imagery that strikes a personal chord and to work in a way that reflects your intentions with integrity.

Allow yourself time to linger over an inspiring question rather than dwelling on a successful conclusion. Opening up the mind to possibilities can contribute immensely to more intuitive ways of working. Paradoxically, you may have to spend some time drawing before this can be attained. Be curious. Nurture your mental travels through focusing on craft. On a practical note, you may or may not find what you are

seeking. You may discover something highly unexpected along an unknown path when you were chasing something else.

Spending time working freely, just pushing a brush around on paper, is the perfect escape route from stress and overthinking. You will discover that drawings can 'feel' right because you've allowed yourself to 'be' in your work, while you work. With time, you'll feel more relaxed. Meaning will follow.

Perhaps a sense of rhythm is emerging from the end of your brush or a heightened focus. This will come with much time spent with brush in hand.

If you are learning through courses, talks or books, you are simply acquiring knowledge. But by testing specifics through practice, you can gain a more insightful kind of learning, something meaningful, as it is experienced. Brush drawing is this exciting and immersive experience. Drawing without an 'end goal' is the purist kind of drawing. Whether it's the expansiveness of the landscape or the intimacy of drawing plant life, spontaneous ways of working will arise from a disciplined start. Your logical thinking may tempt you to 'make a picture' as this is what we have been taught; to work purposefully. But the purpose within brush-drawing philosophy is the drawing time itself, and not the 'picture'.

As with any skill there is the possibility of

**Left: *Persicaria orientalis*. A prolific annual plant that can grow to over six feet tall. It combines huge leaves with tiny flowers. This drawing is on hot-pressed watercolour paper.**

changing the very way you experience the world around you because of what you do with brush and paper, line by line. Your hand holds a brush that makes exciting, energized marks. Sometimes these lines are considered. Sometimes they fall off the end of your brush before your mind gets in the way. You are spring cleaning your mind and dismantling desire.

Your ink work may be very exacting, sometimes flamboyant. Allow yourself to discover what just three brushes can do. Time is always part of the equation. Let it be a friend and not a cause of stress: the time you put in, the time it takes for ink on paper to dry and the time to gain experience. After a while you will become more aware of the way the brush sits in your hand and how to use it with strength and control or more playfully.

This chapter includes both intuitive studies and comment on how I happened upon them. I hope this will encourage you to discover some ideas of your own.

Drawing exercise. Big brush, little drawing. Wash and round brush. Mix three ink tints: light, medium and dark. Wash brush. The broadest brushstroke is worked in light ink from the bottom left-hand corner. Draw this line with one sweep of the hand, twisting the brush gradually round as it turns back to the start point. Add the detailing in with the other two ink tints using only the tip of the round brush.

Agate. This little slice of geology is only 7 x 4cm. Millions of years captured in glassy crystal form.

Wash, round and rigger. Very similar marks are used here with the round brush and dark ink, this time to describe a boulder and pine tree. Only the scale of the subject has changed. This weather-blown pine tree clings to the rock, displaying the space around it as well as its precarious position. The detailed rock edges were drawn with the rigger. Minimal tree foliage is indicated.

These trees on the side of a hill have been wind-blown over the years. I wanted to capture their ragged quality. Wet and dry wash brush textures are thrown together. First I drew a few wet marks with just the tip of the wash brush. Then I squeezed out most of the ink and feathered out the brush tip to draw the thin foliage along the top. When this was dry, both round and rigger brushes were used to add in the battered branches and main stems.

A blustery cloudscape worked in two stages, using wash and round brushes. The first, light brush marks extend from the top to the bottom of the study, below the horizon line. The horizon line and darker work were done afterwards. This is one of several exercises worked very quickly. This study is approximately A6 size.

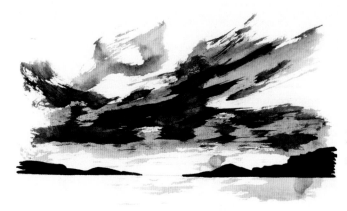

Woodland. Rigger and round. This drawing was done on 300gsm watercolour paper. Here are some experimental brushwork exercises to describe a copse of trees. The underlying light green marks are just smudges of wet ink. It is the additional layers of dark green and rough, rigger brushwork that gives this study some vitality.

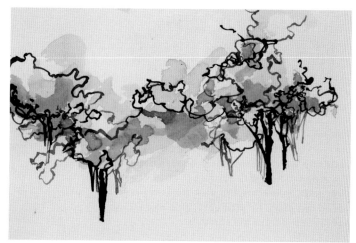

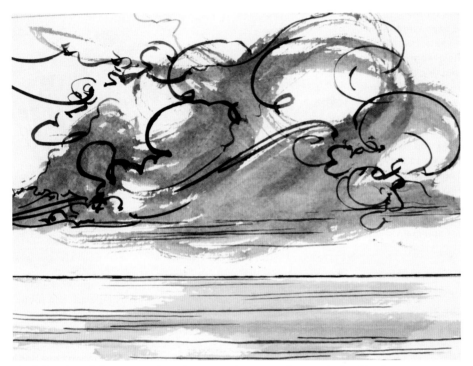

Wash brush and rigger together give strongly contrasting, energized textures.

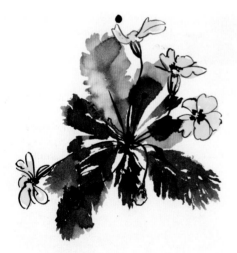

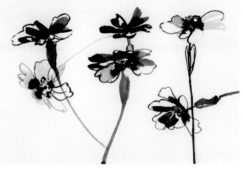

Rigger. One or two flower stems offer plenty of scope for delicate brush practice. These primrose stems are drawn with a mix of solid brushstrokes and outlining: dark and light ink tints.

Primrose. Wash brush and rigger. The leaves are worked with the wash brush held vertically, which creates these uneven edges. The outlined flower heads face in all directions. Yellow ink and dark stems were added last of all. An accidental blob of dark ink has become part of the study.

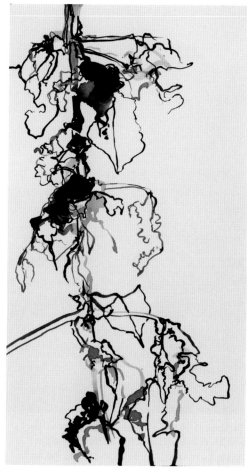

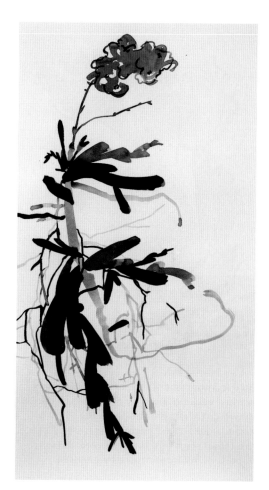

Tomato plant dying back. Rigger. This study was drawn on A4 cartridge directly from a series of old photographs that still inspire me. I spent a lot of time experimenting with different ink tones and practising some curled brushstrokes before I arrived at one or two drawings that worked.

Round and rigger brushes. This orchid drawing fills an A3 sheet of cartridge paper. It is from a series of photographs and sketches done at one of the glasshouses at West Dean Gardens. This orchid shape is more typical of English varieties. The single orchid flower head is dwarfed by the tangle of its untidy leaves and root system. The whole plant was hanging from the roof.

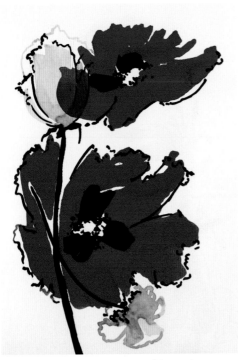

Bold red poppy on A5 paper. This study was worked very quickly after doing lots of pencil drawings to help me decide on the arrangement of the poppy shapes. Although the colour sings out, the marks are still very important. All three brushes were used.

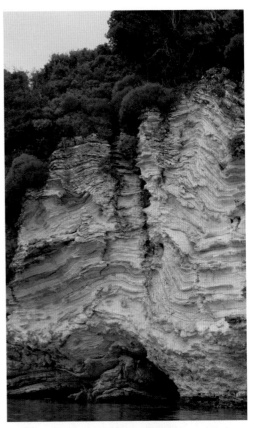

Earthquakes and volcanic activity move rocks and shift mountains. The natural world is always active. This photograph was taken at Lefkas, Greece. The earth's energy has turned this cliff edge into a piece of crumpled tissue.

Doing some explorative pencil drawings of this cliff's ruffled edge led to just a few abbreviated lines. I allowed time and various approaches to take me wherever they would. Much more time was spent with pencil than with brush.

I traced off one of my pencil drawings to ensure the lines of this later ink drawing were all in the same place. This made the brushwork easier. Using the very tip of the rigger I could work the lines freely without concerns of 'quality'. Very dry marks in weak black ink and then blue sets this cliff by the sea's edge. Honing in on a subject through a particular process (in this case, lots of pencil sketches) can lead to interesting places.

# 9 - Finished Studies

## How to Flatten a Drawing

The recommended cartridge paper in this book of 140gsm has a tendency to ripple slightly when wet. This is because the wetted area has shrunk slightly but the dry areas have not. It is not always possible to flatten this quality of paper completely. Because this book's focus is on brush drawing as craft rather than 'paintings', I do not elaborate further on the quality of presentation. For formal work I recommend Hot Pressed (HP) watercolour paper of at least 300gsm. A drawing done on this type of paper is less likely to buckle when wet inks are used. If your finished drawing is slightly buckled, you can press it:

**Dry Pressing:** On a smooth table top, lay your drawing between two larger sheets of cartridge paper and cover this completely with a flat board. Stack some heavy books evenly on top. Leave it for a few days. Your drawing should now be flat.

**Damp press:** If your drawing on watercolour paper is still slightly wavy after dry pressing, you can try dampening the back of it with a clean, wet kitchen towel. Press as before between two sheets of cartridge paper. Leave for a couple of days then allow it to dry out on a table top.

There is no guarantee that your drawing will end up smooth. Sometimes they may wrinkle further after pressing. The risk is yours!

## Using a Split Mount

When you have selected your best drawings, take them to a professional framer for framing. Here's a useful device that will help you decide whether to mount or frame a drawing. Go to your nearest framing shop and buy a large ready-cut mount. (This is an 'open window' cut from good quality card. Your framer will often have a few spare mounts.) White is best but a pale cream is OK.

Be sure to write down the final size of your drawing if you want to have your drawing professionally framed. Do not cut off any excess from your drawing until you are absolutely certain what the finished size will be. Better still, seek the advice of your framer.

Be selective about what work to frame. Ask friends or family for their opinion. My husband's viewpoint is completely different to mine and always useful. Frame your best pieces. Don't forget to add your signature (or stamp) before handing your work to the framer. Ready-made picture frames with mounts can be bought inexpensively from shops or online. Choose a plain black or white frame of good quality.

**Left: Tokonoma. This drawing sits in an 'artplace' or tokonoma, a simple alcove or recess in the Japanese home where art, flowers and simple objects can be displayed.**

Cut the mount through at the top left and bottom right corners so you have two 'L' shapes. The width of this mount is 5cm.

This split mount can now be moved around on top of your artwork till you decide what you want to appear within the mount frame. The mount gives your drawing a more finished look and will help you decide whether to mount it, frame it or both.

## Tokonoma

In a Japanese home may be found a tokonoma. This is a smallish space, traditionally a recess or alcove, where a scroll of calligraphy or a painting may be displayed for the appreciation of the home owner and any visiting guests.

Space is usually in short supply in the modern home, but if you do have such a space, your framed drawing perhaps together with a couple of flower stems in a vase will complement your artwork. A hidden spotlight will enhance your display even more.

Three related drawings placed together (a triptych) will give your artwork an even stronger presence, and will require more wall space, perhaps on a sitting room wall.

# Conclusion

Exercises based on the 'correct' way to hold and use the brush can lead to many hours of drawing. Eventually however, these pointers may just become a passing notion. This may be new terrain for the novice. How you personally draw will evolve over time. It is an explorative journey: a learnt craft with the possibility of a personal awakening. For the experienced artist, old working habits that have become stale can be discarded while new ways of learning are embraced. Learning through experience rather than constant fact-collecting or critique is Zen. How you approach drawing, or any other craft, is Zen practice. Within calligraphy and the art of brush drawing, this is a profound idea because you are always learning from this simple mark making. It will be what it will be on the day. I have tried to embrace this concept in a celebratory way – most importantly, though, in a very positive way.

As you continue to work over time, an inner equilibrium can be accessed, a place of peace. A feeling of 'right way' of your own may take some time. I have found not only a 'right way' for myself, I have found myself. Brush drawing has gathered together the threads of different mental and spiritual worlds, West and East, and created a practical safety net of being through drawing.

These have been some of my experiences with the brush. As is often the case with art, they may seem contradictory!

- The traditional lines of calligraphy are adumbrated in specific ways. Some will have strength, others will have a gentle flow. Some will be refined. Sometimes they will make themselves.
- A calligrapher is a maestro of lines and marks.
- This is both freedom and discipline.
- Over time you will discover a repertoire of marks and lines that are you.
- The same marks and lines can be used for many different subjects.
- Never expect and you'll never be disappointed.
- Brush drawing is food for the soul as well as a stretch for the intellect.
- Brush drawing is a skill that can empower its creator.
- Anyone can learn this skill.

Every artist must explore not only the technical aspects of brush craft but the philosophical or spiritual elements too if they want their work to have greater meaning. This is a very personal experience and can on occasion be profoundly insightful.

Drawing as often as you are able is an acknowledgement of your presence in the world, your tangible connection to nature and its changing seasons; a pursuance of a state of grace. It is an arena that is always open to possibilities and a place where the 'self' can be absorbed into activity.

We are bombarded every time we visit our computers with doubtful 'facts' and things we haven't asked for, but brush drawing is not only an escape from IT and a virtual world, it is a tangible road to reality. It is up to us to be more selective about what we access in the world around us. On the plus side, the internet is now invaluable for accessing art, science and the research that can contribute much to our learning.

Over the years I have questioned (with brush in hand) what influences and philosophies have held true. Some have been adopted. Many have been discarded. I have always wanted to test things over time. Certainly I have found Buddhist philosophy and its precedents gentle on the soul. They encourage a nudge along our personal timeline of self-discovery while allowing us to pose our own questions, in our own way. The natural world can be our guide. It is ever-changing and is always available to absorb any ebb and flow of mental activity that we so often identify as 'self'. Nature offers us the surety that we are as itself: untidy but always growing. Now more than ever, we must be respectful of the natural world around us. We must return to being nature's guests, not its oppressors.

**East:** The traditions of art and crafts from the Far East have survived for hundreds of years because they hold some profound truths that continue to be relevant to today's lifestyles. These are their philosophies. Chinese characters are a highly visual language and art form that has both aided and amplified the communication of these philosophies: phonetics and meaning pressed into each square character. Even in the West we can appreciate the visual power of one of the world's longest living languages.

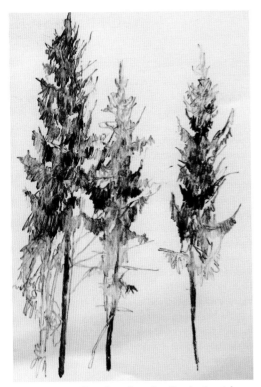

**Pencil and coffee drawing. Saalbach, Austria.**

The brushed lines that were so essential to communication hundreds of years ago have undergone many transformations. Calligraphy and its inherent philosophies pulled language into the realms of art and beauty through these brush-drawn lines. This dynamic art form is still followed today and is just part of a cultural arena that we can now engage with. It is one in which an open-ended, questioning premise allows both knowledge and confidence to grow through experience.

**West:** I could pretend that the ineffable energy from the East called chi has been my only guide but this has not been so. There is the creativity, positivism and pure drive of British determination in there too. Enquiry into the realm of cognition and how the senses function means that being at home 'in my head' is important too. This is a more analytical, or Western, equivalent of chi. I couldn't have appreciated one without the other.

The Far East has supplied plenty of inspiration on the quality of the brush-drawn line to inspire how I work. It has taught me that one mark mastered can draw many different subjects. How the brush feels in the hand is as important as the marks it can make and this is for every artist to discover. Whether of Zen (an allowing of time to pass) or of determination (on decisions made), it can be a deeply personal journey.

A combination of these two aspects of learning: Zen philosophy (East) and mental analysis (West), might be called 'a place for the self' and yet it is beyond this. It is a place of freedom. A space place that every artist can discover. Space is and will remain the most important thing for us all.

As an artist, you will find ways that work for you. Adopt and nurture your intuition. Sometimes it is better to raise a *sail and catch t*he wind rather than turn on the engine and drive. If you do *wish to set yourself some particular parameters, you can change or move these over time. Uncertainty may arise but you can convert the word 'doubt' to the pro-active 'a*dventure', then you can have one every day!

There is a place in nature and the cosmos where pure chi can be found, absorbed and returned through the act of drawing. Brush, ink, paper and you (the artist) are as the four treasures: the perfect partners for describing all of this wonderment.

As a question is more significant than a conclusion – where will the brush take you?

# Resources

Ashmolean Museum, Oxford
https://www.ashmolean.org/
British Museum, London
https://www.britishmuseum.org/
National Gallery, London
https://www.nationalgallery.org.uk/
Tate Britain (Clore Gallery), London
https://www.tate.org.uk/
Cittaviveka Buddhist Monastery, Sussex, UK
cittaviveka.org
Hong Kong Museum of Art
https://hk.art.museum/en_US/web/ma/home.html
The Metropolitan Museum of Art, N.Y. https://www.met-museum.org/
Berkeley Art Museum and Pacific Film Archive, California
https://bampfa.org/
Ryoan-ji (dry landscape garden), Kyoto, Japan
http://www.ryoanji.jp/top.html
China Online Museum
http://www.chinaonlinemuseum.com/
www.theartofcalligraphy.com

# Bibliography

The Mustard Seed Garden Manual of Painting
Macfarlane, Robert, *The Wild Places* (Granta Books)
Gibran, Kahlil, *The Prophet* (Doubleday)
D.T. Suzuki, D.T., *An Introduction to Zen Buddhism* (Grove Atlantic)
Deakin, Roger, Wildwood: *A Journey Through Trees* (Free Press)
Miles, Archie, Silva: *The Tree in Britain* (Ebury Press)
The Royal Horticultural Society, Gardeners' Encyclopaedia.
Khoo Seow Hwa and Penrose, Nancy L., *Behind the Brushstrokes: Appreciating Chinese Calligraphy* (Asia 2000)
Wilhelm, Richard, and Ostwald, H.G. (eds) *Tao Te Ching; Lao Tzu* (Arkana Routledge)
Persig, Robert, *Zen and the Art of Motorcycle Maintenance* (Harper Collins)

# Art Suppliers

Seawhite of Brighton https://www.seawhite.co.uk/
Jackson's Art Supplies www.jacksonsart.com

# Index